W9-CUB-146

Richard Serra
Weight and Measure 1992
Tate Gallery London

Richter Verlag Düsseldorf

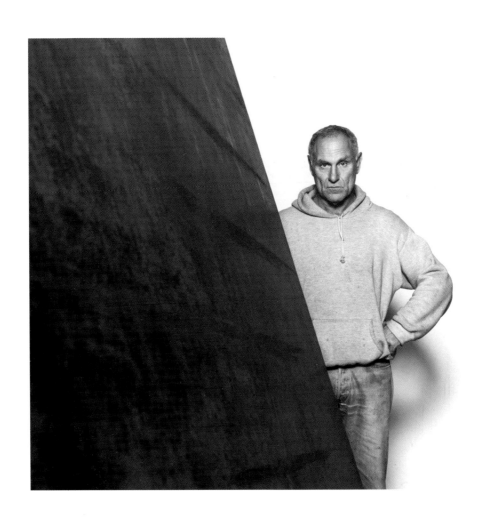

R

Richard Serra Weight and Measure 1992

30 September 1992 – 15 January 1993

Tate Gallery London

Riverside Community College
Library
4800 Magnolia Avenue
Riverside, California 92506

SEP '96

NB 237 .S46 A79 1992

Serra, Richard, 1939-

Richard Serra

Contents / Inhalt

© Copyright 1992
Tate Gallery, David Sylvester,
Richter Verlag
All rights reserved/Alle Rechte vorbehalten

ISBN 1-85437-109-6
Tate Gallery, London

ISBN 3-928762-07-9
Richter Verlag Düsseldorf

Foreword / Vorwort

We were delighted when Richard Serra accepted our invitation to make a new work for the central sculpture galleries of the Tate, the third in a regular autumn series of exhibitions which demonstrate a sculptor's response to the space. Serra has been making sculptures for specific sites for over twenty-five years and this catalogue documents his site-specific indoor installations.

'Weight and Measure' 1992, by virtue of its mass, presented us with a formidable challenge at many levels. We are deeply grateful to all who rose to this challenge and have helped us to realise this project and especially Stuart Lipton and Peter Rogers of Stanhope Properties PLC.

In addition, we should like to thank each of the following for their generous contributions: British Steel General Steels and Mr E.V. Girardier, Director of the Steel Construction Industry Federation; Len Minshull of Bovis Construction Ltd; Tony Fitzpatrick and Adrian Falconer of Ove Arup & Partners; Bryan Perry and Stuart Taylor of Wyseplant Ltd; Robert Knight, Dee James and Chris Bacon of Davis Langdon & Everest.

Further help has been given by the Henry Moore Foundation; by Bernhard and Marie Starkman through Starkman Library Services; and by the Tate Gallery Corporate Membership Programme, which is designed to strengthen ties between the business community and the arts. We are immensely grateful to them all.

However, our most profound thanks go to Richard Serra himself and to Clara Weyergraf-Serra, to H.-L. Alexander von Berswordt-Wallrabe, Trina McKeever and Bruce McAllister for their commitment to the realisation of this challenging sculpture.

Nicholas Serota
Director

Wir waren hocherfreut, als Richard Serra unsere Einladung annahm, eine Arbeit für die zentralen Ausstellungsräume für Skulpturen der Tate Gallery zu erstellen. Es ist für uns das dritte Mal, daß im Rahmen einer Serie von regelmäßigen Herbstausstellungen ein Künstler sich mit dem Thema Raum auseinandersetzt.

Serra schafft seit mehr als fünfundzwanzig Jahren ortsspezifische Skulpturen, die in diesem Katalog dokumentiert werden.

‹Weight and Measure›, 1992, stellte uns aufgrund ihrer Beschaffenheit auf mehreren Ebenen vor eine gewaltige Herausforderung. Allen, die sich ihr stellten und uns halfen, das Projekt zu realisieren, insbesondere Stuart Lipton und Peter Rogers von Stanhope Properties PLC schulden wir unseren besonderen Dank.

Darüber hinaus richten wir unseren Dank für die großzügige Unterstützung an: British Steel General Steels und Herrn E. V. Girardier, dem Direktor von Steel Construction Industry Federation; Len Minshull von Bovis Construction Ltd; Tony Fitzpatrick und Adrian Falconer von Ove Arup & Partners; Bryan Perry und Stuart Taylor von Wyseplant Ltd; Robert Knight, Dee James und Chris Bacon von Davis Langdon & Everest. Weitere Unterstützung wurde uns zuteil durch die Henry Moore Foundation, Bernhard und Marie Starkman von Starkman Library Services und durch das Tate Gallery Corporate Membership Programm, dessen Zielsetzung es ist, die außergewöhnliche Sammlung der Tate Gallery mit ihren Ausstellungen einer breiteren Öffentlichkeit näher zu bringen. Dafür ist ihnen gesondert zu danken.

Unser größter Dank gilt Richard Serra sowie Clara Weyergraf-Serra für ihre ständige Unterstützung. Ebenso danken wir H.-L. Alexander von Berswordt-Wallrabe, Trina McKeever und Bruce McAllister, die uns in jedem Stadium der Realisierung dieses ungewöhnlichen Projektes mit Rat und Tat zur Seite standen.

Nicholas Serota
Direktor

Above right, and illustrating the interview: Work in progress on *Weight and Measure* at the steel mill VSG-Henrichshütte, Hattingen, Germany, 1992

Oben rechts und Abbildungen im Interview: Herstellung der Schmiedeblöcke *Weight and Measure* in der VSG-Henrichshütte, Hattingen, 1992

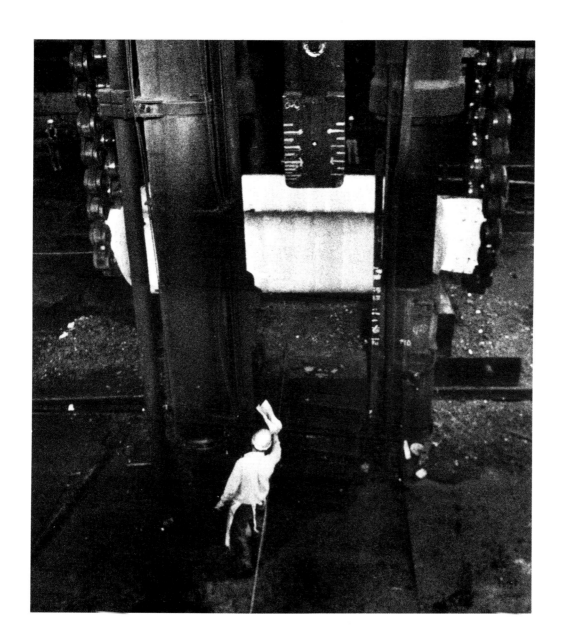

Nicholas Serota: Kannst Du die Überlegungen wieder-
geben, die bei der Entwicklung des Konzeptes für
die Skulpturen-Ausstellungsräume hier in der Tate
Gallery eine Rolle spielten?

Im Grunde sind die ‹Duveen Galleries› eine
große Halle, zusammengesetzt aus drei
von einander abgetrennten, allerdings fort-
laufenden Räumen, die auf einer Linie
angeordnet sind und in die Nebenräume
links und rechts münden. In der Mitte,
zwischen ‹Nord- und Süd-Duveen›, befindet
sich der dominierende Raum des ‹Sackler
Oktogons›. Insgesamt ist die Architektur
überzogen, autoritär und ein wenig über-
gewichtig. Sie ist ein bißchen wie: «Du
sollst diesen Weg gehen und dann die
Seitengänge nehmen.» Ich wollte diesem
Raum eine andere Bedeutung geben, und
ich hoffe, daß es mir gelingt. Ich will die
Intentionen dieser Architektur nicht unter-
stützen, sondern ins Bewußtsein bringen,
wie man über sie denkt. Ich will sie bloß-
stellen, indem ich in die ‹Duveen Galleries›
zwei Volumina plaziere und das Oktogon
leer lasse. Diese beiden Volumina oder
Blöcke werden Gewicht und Masse haben,
welche denjenigen der Architektur vergleich-
bar sind. Bisher hat es mich immer irritiert,
daß den meisten Arbeiten, die ich in den
‹Duveen Galleries› gesehen habe, jede
physikalische Manifestation fehlte, die der
Übergewichtigkeit der Architektur etwas
entgegensetzt. Ich hoffe, daß ich den Raum

im Verhältnis zu seinem Volumen fassen und
dieses im Verhältnis zu seiner Ausdehnung
halten kann. Die beiden Elemente, die ich
verwenden will, werden ein Seh-Feld bilden,
in dem der gesamte Raum eine Skulptur-
Manifestation wird. Ich will nicht, daß die
skulpturalen Elemente als zwei voneinander
getrennte Objekte in zwei gegenüberliegen-
den Ausstellungsräumen verstanden werden.
Die Schmiedestahlblöcke werden auf der
Hauptachse mit einem Abstand von etwa 40
bis 43 m auf einer Linie mittig ausgerichtet
sein. Sie sind ca. 2,75 m (jetziges Maß
2,80 m) breit, vom Abstand zwischen den
zentralen Säulen maßstäblich abgeleitet. Ein
Element ist 173 cm, das andere 152 cm hoch.
Das niedrigere wird in der ‹South Gallery›
plaziert, das andere in der ‹North Gallery›,
so daß sie beim Betreten der Halle infolge
der Perspektive gleich hoch wirken.

Beide Elemente werden ca. 104 cm dick
sein. Ich strebte eine physikalische Größe
und Masse an, die als Gegengewicht zu den
Säulen und zu dem Gewicht von deren Stein-
Material wirken. Ich wollte nicht, daß man
die Blöcke als Scheiben, Schnitte, Linien
oder Platten versteht; vielmehr will ich das
Gewicht durch Wahrnehmung erfahrbar
machen. Ich glaube, daß die Bodenfläche
genug aktiviert ist, um die Funktion der
plastischen Elemente erkennbar zu machen.
Es muß genügend Spannung in der Boden-
fläche sein, um die Präsenz im Raum er-
fahrbar zu halten. Du kannst fragen, warum

Richard Serra

Interviewed by Nicholas Serota and David Sylvester
27 May 1992

Interview mit Nicholas Serota und David Sylvester
27. Mai 1992

Nicholas Serota: Can you describe the thought processes involved in developing the ideas for the sculpture galleries here?

The Duveen Galleries are basically a large hallway formed by three separate but continuous rooms strung out in a line, which empty into the side galleries to the right and left. In the middle, between north and south Duveen, is the highly defined geometric space of the Sackler Octagon. The Octagon is the dominant space. The architecture as a whole is overblown, authoritarian and a bit heavy-handed. It is a little bit 'Thou shalt walk this way and then take the side aisles'. What I wanted to do, and what I hope I am doing, is to bring another relevance to that space. I do not want to reinforce the intentionality of the architecture but redirect how one thinks about it. I want to expose it by placing two volumes in the Duveen Galleries, leaving the Octagon empty. These two volumes, or blocks, will have a weight and mass comparable to that of the architecture. What I have found disconcerting with most works I have seen in the Duveen Galleries is that they usually lack any physical manifestation that can counter the preponderance of the architecture. I hope to be able to contain the space in relation to its volume and hold its volume in relation to its scale. The two elements I decided to use will set up a visual field where the entire space becomes a manifestation of sculpture. I do not want the sculptural elements to be read as separate objects in the two opposing galleries. The forged blocks will be centred on line with the main axis, placed 130-140 feet apart. They are approximately nine feet (exact measure 108 $^{1}/_{2}$ in) wide, scaled to the distance between the central columns in the Sackler Octagon. One element is sixty-eight inches high, the other is sixty inches high. The lower element is placed in the south gallery, the higher element in the north gallery, so that when you enter the hall, they will appear level due to perspective. Both elements will be forty-one inches thick. I wanted a physical scale and mass which would act as counterweight to the columns and the weight of the stone. I didn't want the blocks to

ich das nicht in Gips mache. Das hat Gia-
cometti gemacht. Heute morgen habe ich
Degas' Tänzerin gesehen. Ich kam zu dem
Schluß, daß die Art, in der seine Skulptur
die gesamte Räumlichkeit eines Raumes
geradezu in sich aufsaugt, ziemlich gut ist.
Mit Ausnahme Giacomettis sind aber nur
wenige gegenständliche Bildhauer dazu in
der Lage. Löcher in den Raum zu schlagen,
war meine Sache noch nie.

*David Sylvester: Kannst Du Dich an die ver-
schiedenen Entwicklungsstadien erinnern, die Du
in Bezug auf Deine Reaktion auf den Raum
durchmachtest?*

Zuerst mußte ich mich entscheiden, wie ich
den Raum benutzen wollte; sollte ich eine
separate Arbeit in jedem Bereich aufstellen
oder die Wahrnehmungsgrenzen der Halle
als gegeben akzeptieren und eine Arbeit
ausdenken, welche die Gesamträumlichkeit
aufnimmt? Mir fiel sofort auf, daß die Säulen
ein großes Problem waren, sie sind von enor-
mer plastischer Präsenz. Bekennt man sich
einmal zu den Säulen, bekennt man sich
damit auch zur vertikalen Größe des Rau-
mes. Außerdem hatte ich mich mit der Weite
der horizontalen Fläche auseinanderzuset-
zen. Ich wollte die Richtungskonzentration
und die Linearität der Mittelachse nutzen.
Kommt man aus den seitlichen Galleries in
den Raum zurück, dann ist der Übergang
uninteressant. Es ist so, als käme man durch
einen Tunnel in ein Fußballstadion. Ich

dachte daran, der Länge nach in der Halle
eine Reihe von Abteilungen zu schaffen, die
sie rhythmisch teilen und separate Räume
entwickeln würden. Ich begann mit fünf
Elementen. Ich ließ Leute sich an verschie-
denen Stellen aufbauen, um Verhältnismä-
ßigkeiten herzustellen.

Das Mittel-Oktogon ist das Hauptpro-
blem der Duveen-Galleries. Es wird als
abgetrenntes vertikales Volumen verstanden
und übernimmt die Funktion eines Podestes,
ohne wirklich eines zu sein. Man kann sich
von der vertikalen Aufwärtsbewegung kaum
lösen. Wenn Du bewegungslos in der Mitte
des Raumes stehst, rempelt Dich jeder an,
der in die Galleries gehen will. Ich mußte
einen Weg finden, diesen übermäßig defi-
nierten Mittelpunkt gleichzeitig zu meiden
und zu nutzen.

Ich kam zu keinem Ergebnis, bis ich die
Elemente erst auf vier, dann auf drei redu-
zierte, selbst bei dreien hatte ich immer noch
eines in der Mitte. An diesem Punkt wurde
uns klar, daß wir die Arbeit aus dem Zentrum
wegbewegen und sehen mußten, ob wir den
Raum mit zwei Elementen halten konnten.
Erst da erkannten wir, daß wir auf dem rich-
tigen Weg waren. (Ich sage wir, weil Clara
meistens Partner des Dialogs ist.) Nachdem
ich die Arbeit erst einmal von drei auf zwei
Elemente reduziert hatte, war ich zuversicht-
lich, daß sie die Volumina beider ‹Galleries›
halten und quer durch das Oktogon eine
Verbindung schaffen könnte, die den gesam-

be read as slices, cuts, lines, plates; I rather want to make the weight perceptually accessible. I think that there will be enough agitation in relation to the field that the function of the sculptural elements will be acknowledged. There must be enough tension within the field to hold the experience of presence in the place. You can say, why couldn't you do that with a sliver of plaster? Well, Giacometti did that. Also, I looked at Degas's dancer this morning and came to the conclusion that the way in which his sculpture drinks the whole space from the room right into its grasp is pretty good. But very few figurative sculptors, with the exception of Giacometti, are able to do that. Punching holes through spaces never did it for me.

David Sylvester: Can you remember the various changes of mind you went through as to how to respond to that space?

Initially, I had to decide how to use the space, whether to place a separate work in each room or to accept the perceptual boundaries of the hall as a given and conceive a work which dealt with the entire space. I realised immediately that the columns were a big problem; they have an enormous sculptural presence. Once you acknowledge the columns you acknowledge the vertical scale of the room. I also had to contend with the vastness of the horizontal field. I wanted to use the directionality and linearity of the central axis. Walking in from the side galleries never did me much good. When you come back into the space from the side galleries the transition isn't one that is of interest. It is like coming into the football stadium through a tunnel. I thought about setting up a series of divisions throughout the length of the hall which would demark it rhythmically, creating separate spaces. I started out considering five elements. We stood people at various locations over the distance to establish a scale reference.

The big trap in dealing with the Duveen Galleries is the centre Octagon. It reads as a separate vertical volume and, without being an actual pedestal, it takes on the function of a pedestal. You cannot get away from its vertical rise. In fact, if you stand in the centre of that space and don't move, everybody who walks in the gallery tries to bump you over. I needed to come up with a solution which avoided this overly defined focal point and used it at the same time. I did not reach a conclusion until after I had reduced the elements to four and three and at three I still had one in the centre. At that point it became clear to us that we had to remove the work from the centre and see if we could hold the space with two elements. Only then did we feel that we were moving in the right direction. (I say we because Clara is part of the dialogue, always and continuously.) Once the work went from three to two elements I was confident that it could hold the volumes of both galleries and make a linkage across the Octagon, activating the entire space. The proof of the pudding is in the work. We'll see.

ten Raum aktiviert. Die Arbeit wird den Nachweis liefern müssen.

D.S. Wann hast Du die Entscheidung bezüglich der Formen getroffen?

Ich begann mit Rundformen. Ich hatte die Vorstellung, runde Schmiedestahl-Blöcke zu verwenden und ihr Maß von dem der Säulen abzuleiten. Dieses Konzept tappt jedoch geradewegs in die Falle eines postmodernen Kontextualismus. Der Zusammenhang zwischen den Rundformen und den Säulen wäre allzu offensichtlich gewesen. Eine derartige postmoderne Konfusion wollte ich nicht. Ich hatte keine Lust, mich auf einen affirmativen Dialog mit dem Gebäude einzulassen. Es interessierte mich überhaupt nicht, die äußere Sprache der Architektur, ihre Physiognomie, zu reflektieren. Vielmehr interessiert mich das Volumen, das Gewicht, die Masse und die Richtungsbezogenheit des Raumes. Erst als ich Rundformen ausschloß, wurde das Problem interessanter.

N.S. Wurde es das, weil Du aus dem gesamten Raumvolumen eine Skulptur machen wolltest?

Genau das! Ich will das Volumen des Raumes direkt begreifbar machen, physisch, mittels des eigenen Körpers; nicht so, als sei die Skulptur ein Körper in Verhältnis zum eigenen Körper, sondern so, daß man das Volumen dadurch als Ganzes erfahren kann, daß es durch die Einbringung von zwei plastischen Elementen verdeutlicht wird.

D.S. Du hast dann von Rundformen auf Oktogonen übergewechselt. Geschah das bei Deinem zweiten Besuch? Da wolltest Du doch fünf Oktogone einsetzen?

Möglich. Ich habe kürzlich ein Schmiedestahl-Oktogon vor einer romanischen Kirche aufgestellt. Eine zeitlang dachte ich daran, Oktogone zu verwenden, fand dann aber, daß die Aktivform des Oktogons zuviel Aufmerksamkeit auf sich selbst ziehen würde. Für diesen Raum wäre sie zu unruhig. Sie würde zu schnell als interessantes Objekt verstanden werden.

D.S. Du hast dich mit einem anderen Problem intensiv beschäftigt, wie ich erinnere, mit der Verschiedenartigkeit der Raumstrukturen. In ‹North-Duveen› verspringen die Wände mit Nischen, ‹South-Duveen› hat gerade Wände mit Türöffnungen. Erinnerst Du Dich noch an Deine damaligen Überlegungen?

Die nördliche ‹Gallery› hat Nischen, welche die Richtungsbezogenheit auflösen und den Raum in sich teilen. Das macht den Unterschied in der Orientierung zwischen der ‹North-› und ‹South-Gallery› aus. Ich war sehr besorgt, daß der Raum der ‹North-Gallery› sich in diesen Seitennischen, diesen großen Schattenkästen, verlieren würde. Ich hatte keine Vorstellung, wie ich ihre Präsenz vermeiden sollte. Sie sind zu klein, um als Räume zu gelten und zu groß, um als Nischen für Plastiken zu funktionieren. Erst als ich die

I started with circles. I started with the ideas of using forged rounds, taking the scale of the rounds from the scale of the columns. I dropped the idea. Conceptually it falls right into the post-modernist trap of contextualisation. The linkage between the columns and the rounds would have been too evident. I did not want that post-modernist confusion. I did not want to enter into an affirmative dialogue with the building. I did not want to mirror face-value language, the physiognomy of the architecture. I wanted to deal with the volume, weight, mass and directionality of the space. It was not until I dismissed the rounds that the problem became more interesting.

N.S. Was that because you wanted to make a sculpture out of the whole volume?

Yes, that's it in a nutshell. I want to make the volume of the space tangible, so that it is understood immediately, physically, by your body; not so that the sculpture is a body in relation to your body, but that the volume, through the placement of the sculptural elements, becomes manifest in a way that allows you to experience it as a whole.

D.S. But then you moved from rounds to octagons. Was that on your second visit? At that stage you seemed to be thinking of using five octagons.

Maybe. I had recently installed a large forged octagon in front of a Romanesque church in Burgundy. To work with octagons was on my mind. And for a while I thought I would use them, but the active shape of the octagon draws too much attention to itself. It is too busy for this space. It can be too easily read as an interesting object.

D.S. The other thing that was occupying you very much, I remember, was the way the north Duveen goes in and out, the way it has recesses, whereas the south Duveen has straight walls but also openings. Can you reconstruct what you were thinking?

The north gallery has niches which dissolve the directionality of the main axis and compartmentalise the space. This accounts for the difference in orientation between the north and south gallery. I was very concerned that the space of the north gallery would dissipate out into these side pockets, these large shadow boxes. I didn't know how to avoid their presence or how to interact with them. They are too small to be rooms and too large to function as niches for sculpture. It was not until I decided the horizontal width of the forged blocks to be nine feet that I realised that I could hold the space of the north gallery regardless of the niches. The width as well as the height of the elements were crucial decisions. When you

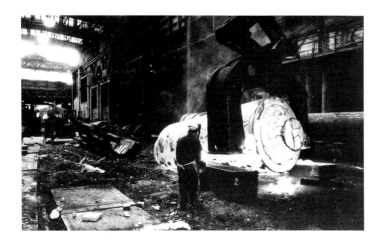

horizontale Breite der Schmiedestahlblöcke
mit 2,75 m entschied, war ich überzeugt, daß
ich den Raum der ‹North-Gallery› halten
konnte. Breite wie Höhe der Elemente waren
wesentliche Entscheidungen. Beim Betreten
der Tate Gallery werden beide Blöcke gleich
hoch erscheinen. Ich glaube nicht, daß man
ihren Höhenunterschied bemerkt, bevor man
das zentrale Oktogon betritt und vor- und
zurückschaut.

Die Spannung der Arbeit resultiert aus
ihrem Höhenunterschied, aus der Tatsache,
daß man ein Element als ein horizontales
Volumen liest, dessen unter Augenhöhe
liegende Oberfläche überschaubar ist, wo-
hingegen das andere sich vertikal bis über
Augenhöhe erhebt, wenn man darauf zugeht.
Es dreht die Erwartungen in bezug auf seine
Höhe um, wenn man sich ihm nähert.

*D.S. Als Du die Idee vom Oktogon verwarfst,
kamst Du direkt zur Rechteckform?*

Nicht bevor wir zurückkamen und den
gesamten Raum neu ausmaßen. Maßnehmen
ist für mich kein Hilfsmittel für Schlußfolge-
rungen. Es ist vielmehr ein Prozeß, der mir
hilft, mich selbst im Raum zu lokalisieren,
den Raum in bezug auf meine eigene körper-
liche Bewegung zu begreifen.

*D.S. Du hast Dich für Rechtecke entschieden, als
Du den Raum ausgemessen hast?*

Nicht sofort. Ich hatte einen genauen Kon-
struktionsplan. Trotzdem habe ich den Raum

zwei- oder dreimal neu vermessen: den
Durchmesser der Säulen, den Fuß der
Säulen, den Abstand zwischen den Säulen,
die Nischen und die Wandflächen zwischen
ihnen, die Durchgänge, eben alles. Nachdem
ich erst einmal entschieden hatte, daß die
Breite der Elemente der Weite zwischen den
Mittelsäulen entsprechen sollte, habe ich
eine Entscheidung für ihr Höhen-, Dicken-
verhältnis gesucht. Ich entschied, daß das
eine Element 152 cm hoch sein sollte. Da-
durch konnte man seine Oberfläche sehen.
Ich wollte, daß es dick genug war, es als
Masse und nicht als Scheibe, Linie oder
Fläche zu verstehen. Ich begann mit einer
Dicke von 91 cm. Dieses Maß war mir sofort
zu standardisiert, zu bekannt, ein Möbel-
Maß. Die Holz-Modelle zeigten, daß die
Dicke von 104 cm die Elemente massiv genug
sein lassen würde, um sie als Volumina im
Verhältnis zum Raumvolumen zu verstehen.
Ich erarbeitete das Verhältnis von Skulptur
und Standort mit Modellen in situ. Es ist fast
unmöglich, sich Maß und Maßverhältnisse zu
merken. Das Problem des richtigen Maßsta-
bes läßt sich nicht auf dem Zeichentisch
lösen. Maßstäblichkeit läßt sich nich vorab
denken und dann auf Millimeterpapier zeich-
nen.

*D.S. Also stellte sich nie die Frage, das Oktogon
durch einen Würfel zu ersetzen?*

Aus dem gleichen Grund, aus dem ich den
Gedanken verwarf, Oktogone zu verwenden,

enter the Tate Gallery both blocks will appear equal. I don't think that you will realise their difference in elevation until you enter the central octagon and look back and forth.

The tension of the piece is based on its difference in elevation, on the fact that one element reads as a horizontal volume, its top plane clearly below eye level, whereas the other will rise vertically above your eye level as you walk towards it. It reverses the expectation of its height as you approach it.

D.S. And then did you go from discarding the octagon straight to the idea of the rectangle?

No, it wasn't until we came back and actually remeasured the whole space. Measuring for me isn't directed toward geometric conclusions. It is a process that allows me to locate myself in the space, to understand a space in terms of my physical movement.

D.S. When you did these measurements you decided it had to be rectangles?

No, not immediately. I had a precise engineering plan, but I nevertheless remeasured the space two or three times. I measured everything, the diameter of the columns, the base of the columns, the distance between the columns, the niches, the plane of the wall between them, doorways, everything. Once I decided that the width of the elements would equal the width between the central columns, I tried to come to a conclusion about their height in relation to their depth. I decided that I wanted one element to be sixty inches high which would allow you to see its top plane. I wanted it to be deep enough so that it would read as a mass and not as a slice, line or plane. I started out with a depth of thirty-six inches. It was too standardised, too familiar, a furniture scale. The mock-ups confirmed that the depth of forty-one inches would make the elements massive enough to be understood as volumes in relationship to the volume of the space. Scale in relation to place has to be worked out with mock-ups in situ. One has little retention for scale and scale relationships. The problem of scale cannot be resolved through design solutions; you cannot preconceive scale and draw it up on graph paper.

D.S. So there was never any question of the octagon being replaced by a cube?

I dismissed the idea of using cubes as quickly as I dismissed the idea of using octagons and for the same reason. They would have been read as objects in the galleries. I've only forged one large cube. It is very absolute to forge a cube.

D.S. Having got the idea of the rectangle, how many did you begin with: three?

Five.

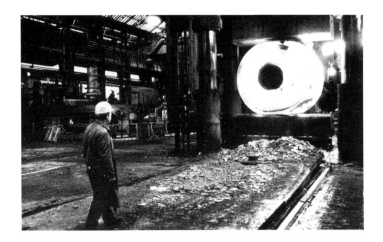

ließ ich auch denjenigen an Würfel fallen. Man hätte sie als Objekte in den Galleries gesehen. Ich habe überhaupt nur einen großen Würfel geschmiedet. Es ist ziemlich ausschließlich, einen Würfen zu schmieden.

D.S. Nachdem Du dann die Idee mit den Quadern hattest, hast Du mit dreien angefangen?

Mit fünf.

D.S. Als Du daran dachtest, Quader zu verwenden, kamst Du wieder auf fünf Elemente zurück wie vorher bei den Oktogonen?

Zuerst ja, aber wir ließen die Idee fallen, fünf Teile zu benutzen, weil das Serielle ihrer Anordnung der Halle eine formale Komposition aufgedrängt hätte, welche die Installation von den anderen räumlichen Bedingungen des Ortes isoliert hätte. Erst als wir mit Modellen im Maßstab 1:1 gearbeitet hatten, entschieden wir uns für die endgültige Anzahl der Elemente. Die Installation auf zwei Elemente zu reduzieren, war eine Entscheidung, zu der wir nicht gekommen wären, wenn wir nicht diese Modelle probeweise hin- und hergeschoben hätten.

D.S. Kannst Du das immer so machen, oder mußt Du manchmal einfach quasi, ‹prophetische› Voraussagen treffen?

Ich verwende 1:1 Modelle so oft wie möglich. Wenn es physisch unmöglich ist, improvisiere ich mit dem, was machbar ist.

N.S. Der von Dir beschriebene Prozeß des Sich-in-diese-Arbeit-Hineinfindens hat zuerst mit Ausschließen zu tun, mit dem Ausschließen jedes Gedankens an Komposition, da man komponiert, wenn man mit fünf Elementen arbeitet, wohingegen man Komposition im Verhältnis zum Raum ausschließt, wenn man auf zwei heruntergeht. Eine beträchtliche Zahl der Arbeiten, die Du gemacht hast, insbesondere Außenarbeiten, haben Kurvenformen. Hast Du jemals diese Möglichkeit für diesen Raum in Betracht gezogen?

In bezug auf diesen Raum habe ich niemals an eine Kurvenform gedacht. Die wäre zu ausgefallen, zu gestisch. Die Architektur der Duveen-Galleries ist pompös und überladen. Der Raum löst sich in dem Maße auf, in dem er an Höhe zunimmt. Ich wollte den Raum auf das plastische Potential hin konzentrieren, zu dem er sich aufschwingt, das er aber nicht erfüllt. Ich wollte diese Architektur packen, indem ich das benutzte, was vorhanden war, nicht, indem ich das Vorhandene neu zu fassen versuchte. Eine Kurvenform hätte möglicherweise aus dem vorhandenen Volumen einen separaten Raum herausgeschält.

D.S. Hast Du das Problem des Lichteinfalls bedacht, wie das Licht in dieser Halle auf die Plastik fällt, nämlich aus großer Entfernung? Oder hast Du unterstellt, daß den Bedürfnissen der Arbeit entsprechend Kunstlicht eingesetzt werden könnte?

Licht ist für mich nicht die Hauptsache. Wenn eine Arbeit stimmt, dann nimmt sie die Räum-

D.S. When you thought of rectangular blocks, you were back to five again as with the octagons?

At first, yes, but we dropped the idea of using five parts because the seriality of their placement would have imposed a formal composition on the hall, isolating the installation from the conditions of the place. We only concluded the final number of elements after we started to work with full-scale models. To reduce the installation to two elements was not a decision we could have reached without moving models around.

D.S. Do you always manage to do that or do you sometimes simply have to predict?

I build full-scale models as often as possible. If it is physically impossible, I improvise with what is available.

N.S. The process you've described in resolving this piece has to do with removal – first, the removal of all notions of composition, because when you're working with five you're composing, whereas when you come down to two you lose composition in relation to space. All the forms that you have described are in one way or another square forms, they work with this rectilinear space in a certain way. Quite a number of the pieces you've made, particularly pieces outdoors, have been curved forms. Did you ever consider that possibility in relation to this space?

No, I never thought of a curved form in relation to this space. Too fanciful, too gestural. The architecture of the Duveen Galleries is pompous and verbose, and the space dissolves as it rises. I wanted to concentrate the space to the sculptural potential it aspires to but does not fulfill. I wanted to grasp this architecture by using what was there, not by trying to reshape what was there. There was no way of holding the entire volume with a curve. The problem with a curve would have been that it would have carved a discrete space out of the volume that already existed.

D.S. But did you give thought to the problem of the way light falls upon the sculpture in the hall, from a great distance? Or did you assume that artificial light could be adjusted to suit the needs of the work?

Light is not crucial. If the work is successful it collects the scale of the space no matter what the light conditions. I prefer to work with natural light; I have problems with artificial light. If necessary, I light the space and not the piece, to avoid theatrical effects.

D.S. With your Zurich installation, the changes of natural light in the course of the day worked staggeringly well in relation to the sculpture.

That's not why I titled the work 'The Hours of the Day'. To be correct, the title is borrowed from Blanchot, although the structure is based on twelve units and refers

lichkeit in sich auf, ganz egal, wie die Lichtverhältnisse sind. Allerdings arbeite ich lieber mit natürlichem Licht. Mit Kunstlicht habe ich Probleme. Wenn Kunstlicht unvermeidbar ist, dann beleuchte ich den Raum und nicht die Arbeit, um theatralische Effekte zu vermeiden.

D.S. Bei Deiner Installation im Kunsthaus Zürich funktionierte der Wechsel im natürlichen Licht während des Tagesverlaufs im Verhältnis zur Skulptur hervorragend.

Aber ich habe die Arbeit nicht deswegen ‹The Hours of the Day› genannt. Der Titel ist, offen gestanden, von Blanchot entliehen, wenngleich die Gliederung der Arbeit auf zwölf Einheiten basiert und sich so indirekt auf die Stunden des Tages beziehen läßt. Dies ist die einzige Arbeit, bei der ich tatsächlich darüber nachgedacht habe, ob sie möglicherweise ein narratives Element in Form einer Periode von zwölf Stunden oder zwölf Einheiten haben könnte.

N.S. Was mich am meisten am Unterschied der beiden Arbeiten, der in Zürich und der in der Tate, beeindruckt hat, ist, daß das Gleichgewicht der Skulptur in Zürich sich etwas mehr dem Wahrnehmbaren zuordnet, während diese Arbeit hier eine sein wird, die mit Gesamtgewicht, Masse und Raumgefühl zu tun hat.

Die Arbeit in der Tate ist absoluter. Sie funktioniert hauptsächlich, indem sie die Erfahrung ihres speziellen architektonischen Kontextes ins Bewußtsein bringt. ‹The Hours of the Day› war im Verhältnis zu der sie umgebenden vergleichsweise neutralen Architektur nicht so ausschließlich. Die Wahrnehmung von ‹The Hours of the Day› hängt in ihrer Abwicklung stärker von inwendigen Deutungsmöglichkeiten ab, d. h. von den Schwankungen im skulpturalen Umfeld, wenn man vor- und zurückgeht oder nach links und rechts. Es ist unmöglich, sich selbst zu zentrieren. Der Raum formt Mäanderstrukturen, dehnt sich aus und verschließt sich, zieht sich zusammen und streckt sich, wächst zusammen und verteilt sich. Die Wahrnehmung zerfällt in Momente, kommt zum Stillstand. Irgendwie habe ich ein wenig die Befürchtung, daß die Betrachter an den beiden Blöcken der Skulptur hier in London eine metaphorische oder bildhafte Deutung festmachen könnten, die jede Lesart dieser Arbeit in ihrem Kontext umgehen würde.

Es gibt gewisse Mißdeutungen abstrakter Kunstwerke, die jede Form umfassenden Verständnisses auszuschließen scheinen. Bildhafte und metaphorische Assoziationen führen per definitionem zum Ausschluß der Abstraktion, weil sie sie unnötigerweise von etwas abhängig machen. Das ist eine Möglichkeit, Abstraktion zu domestizieren, zu versuchen, sie in ein Vokabular zu integrieren, das durch Tradition abgesegnet ist.

D.S. Welche Architekturräume fandest Du besonders beeindruckend?

Im letzten Jahr habe ich Le Corbusiers Kapelle in Ronchamp gesehen. Wenn irgend-

obliquely to the hours of the day. That's the only piece where I've actually thought about a work really having a narrative, in terms of a period of twelve hours or twelve units.

> *N.S. What strikes me about the distinction between the two works, the Zurich piece and the Tate piece, is that the balance in the Zurich piece was tilted slightly towards the perceptual, whereas this sculpture is a work that is going to be about overall weight and mass and the feeling of space.*

The work for the Tate is more absolute. It only functions as it focuses the experience on its particular architectural context. 'The Hours of the Day' was not as exacting in relation to the surrounding architecture, which is comparatively neutral. The gallery space in Zurich is a large, well-lighted, undefined container. The perception of 'The Hours of the Day' as it unfolds depends more on its internal readings, i.e. the shifts in the sculptural field as you walk back and forth, right and left. There is no possibility of centring yourself. The space meanders, expands and closes, compresses and elongates, coalesces and separates. The perception breaks down to moments, stops. I am somewhat apprehensive about the possibility that viewers might attach a metaphorical or imagistic reading to the two blocks here, which would circumvent any reading of the piece in context. There are certain misreadings of abstract works that seem to preclude any comprehensive understanding. Imagistic and metaphorical associations lead by definition to the dismissal of abstraction by making it needlessly referential. It's a way of domestic-ising it, of trying to integrate it into a vocabulary that has been canonised by tradition.

> *D.S. Changing the subject, what are some of the architectural spaces that have especially moved you?*

I saw Le Corbusier's Ronchamp Chapel last year. If it is possible that a building can be imbued with feeling, this building is. The way the light streams through the thickness of the walls into the cavernlike containment of the space creates a highly emotionalised atmosphere and allows for a private experience that's rare in all art. The only other building I can think of which has that quality is the Hagia Sofia in Istanbul. At Ronchamp there are emphatic movements in the interior of the space. The space has eccentric and active swings, outward bursting curves juxtaposed with bell towers that trap the light in their vertical volume.

I spent a great deal of time looking at Le Corbusier's notebooks. Those drawings where he manages to see entire frames of reference interest me the most. They represent such a simple way of notating a very complex involvement with space. A few lines will summarise a building on a mountain top, the road leading to it, the horizon, the sea. He made drawings of everything that interested him in a

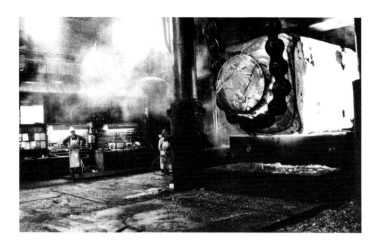

ein Gebäude gefühlsdurchdrungen sein
kann, dann ist es dieses. Dadurch, wie dort
das Licht durch die dicken Mauern in den
höhlenartigen Raum strömt, wird eine hoch-
gradig emotionsgeladene Atmosphäre
geschaffen, die persönliche Erfahrungen
möglich macht, welche in der Kunst kaum
möglich sind. Als einziges anderes Gebäude,
das so wirkt, fällt mir noch die Hagia Sophia
in Istanbul ein. Der Raum erzeugt exzentri-
sche und aktive Schwingungen, nach außen
ausbrechende Rundungen sind gegen Glok-
kentürme gesetzt, die ihrerseits das Licht in
ihren vertikalen Volumina einfangen.

Ich habe mich lange mit den Skizzen-
büchern Le Corbusiers befaßt. Am meisten
interessieren mich die Zeichnungen, in denen
es ihm gelingt, alles in bezug zueinander zu
setzen. Sie zeigen einen einfachen Weg, sich
vielschichtig auf Raum einzulassen. Mit
wenigen Linien werden z. B. ein Gebäude
auf einem Berg, die Straße, die dahinführt,
der Horizont und das Meer zusammenge-
faßt. Er zeichnete, was ihn an einem bestimm-
ten Tag, an einem bestimmten Ort interes-
sierte: Städte, Häfen, ägyptische Grabstät-
ten, Schiffe, Flugzeuge, Kühe, Giraffen,
Affen, einfach alles. Man ist versucht, seine
Aufzeichnungen als flüchtiges Gekritzel
abzutun, bis man erkennt, daß Zeichnungen
auch des trivialsten Sujets Grundlage seiner
Architektur werden können. Schaut man sich
die Skizzenbücher an, erkennt man, daß
Ronchamp eine aus verschiedensten

Ursprüngen bestehende Kombination ist:
eine Moschee, ein Periskop, ein Damm, ein
Krabbengehäuse, der Bug eines Schiffes.

*N.S. Aber hat das nicht alles mit der Tatsache zu
tun, daß der gesamte Prozeß, den Du beschreibst,
ob bei Le Corbusier oder in Deiner eigenen Arbeit,
ein Ausfilterungsprozeß ist?*

Doch, genau. Der Grund, warum mich Le
Corbusier, und was das betrifft, Newman
interessieren, liegt darin, daß Ausfilterung in
ihren Arbeiten nicht Beschränkung ist,
sondern die Synthese verschiedener Bedeu-
tungsebenen. Ich behaupte, daß der Mini-
malismus dagegen auf einer Glaubenslehre
der Beschränkung basiert. Eine der größten
Begrenzungen des Minimalismus ist ironi-
scherweise in seinem Verhältnis zum Um-
feld zu sehen. Seine Werke wurden ursprüng-
lich in und für Loft-Situationen gemacht, die
dann genau von den Galerien in den 70er
und 80er Jahren imitiert wurden, um
wiederum später von den Museen der 90er
Jahre reproduziert zu werden. Dort wurden
sie schließlich zu einem gut ausgeleuchteten,
perfektionierten und neutralisierten Schuh-
karton. Im Zuge der kontextuellen Verdün-
nung wurde so das minimalistische Objekt zu
einem High-tech –, zu einem massenprodu-
zierten Handelsartikel. Ortsbezogenheit
stand bei den Minimalisten immer im Bezug
zu dem vorgegebenen Raum, der perfekte
weiße Würfel. Das erklärt, warum jeder
Versuch, minimalistische Plastik in eine Land-

given day, in a given place: entire towns, ports, Egyptian tombs, ships, aeroplanes, cows, giraffes, monkeys, anything, everything. One might want to dismiss his notations as cursory doodles, until one sees that a drawing of the most trivial subject will end up becoming a source for his architecture. Whether he draws his hand or a hydraulic dam, it all becomes reference material. If you look at the notebooks you realise that Ronchamp is a combination of the most diverse source material, a mosque, a periscope, a dam, a crabshell, the prow of a ship.

N.S. But is that not also to do with the fact that the whole process you're describing, whether it is in Le Corbusier, or indeed in your work, is a process of distillation?

That's right. The reason that Le Corbusier and, for that matter, Newman interest me is that in their work distillation is not reduction, but the synthesis of different levels of meaning. Whereas I would say that Minimalism is based on the theology of reduction. One of the biggest limitations of Minimalism, ironically, is its relation to context. The work was originally made in and for a loft space, which was then imitated by the galleries of the 1970s and 80s, to be reproduced again by the new museums of the 1990s where it is perfected and neutralised into a well-lighted white shoebox. Simultaneous to the rarefaction of the context the Minimalist object turned into a high-tech, mass-produced commodity. Now the container and the contained can both go into circulation. The Minimalist's notion of site specificity was always limited to the room, the perfect white cube. That explains why any attempt to place Minimalist sculptures in the landscape or in urban sites reduces them invariably to homeless objects.

N.S. I notice that you carry notebooks with you. How do you use these and what function does drawing have in your work?

I have been drawing in notebooks for at least twenty-five years. I always carry them with me to mark down ideas and thoughts quickly, often haphazardly. My notebooks are unrefined working tools, a means of recalling spaces and places through drawings, notations, measurements, commentaries. Sometimes they become travel-logs, but usually they refer to daily activities, in some instances to specific projects. They help me to keep eye and hand in touch with what's to be done and what has been done.

My initial engagement in art was through drawing, and drawing is still at the core of my work. I began to draw when I was very young. It is a ritual of sorts. I read almost all art through drawing – my own and everyone else's: from cave paintings to Giacometti, from Cézanne to Brancusi. Drawing is always an indication of how artists think. Offhand I cannot name anyone's work which is worth its salt where drawing isn't a key. When I talk about drawing I don't mean

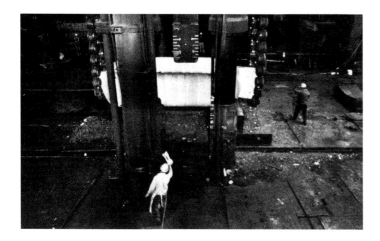

schaft oder in ein urbanes Umfeld zu setzen,
sie ausnahmslos zu einem heimatlosen
Gegenstand reduziert.

*N.S. Mir fiel auf, daß Du Skizzenbücher mit Dir
führst. Wozu brauchst Du sie, und welche Funktion
haben Zeichnungen in Deiner Arbeit?*

Ich zeichne seit mindestens fünfundzwanzig
Jahren in Skizzenbüchern. Ich habe sie immer
bei mir, um Ideen und Gedanken schnell, oft
hastig zu Papier zu bringen. Meine Skizzenbü-
cher sind reine Arbeitsutensilien, Mittel, um
mich mit Hilfe von Zeichnungen, Notizen,
Maßen, Kommentaren an Räume und Orte zu
erinnern. Gelegentlich werden sie zu Reisebe-
richten, aber gewöhnlich beziehen sie sich auf
meinen Arbeits-Alltag, manchmal auch auf
spezifische Projekte. Sie helfen mir, weder das
aus dem Auge zu verlieren, was noch gemacht
werden muß, noch das, was bereits gemacht
wurde.

Ich komme ursprünglich vom Zeichnen
her, und Zeichnen ist immer noch Mittelpunkt
meiner Arbeit. Ich begann zu zeichnen, als ich
noch sehr jung war. Es ist so etwas wie ein
Ritual. Ich untersuche und verstehe fast jede
Kunst, meine eigene und die anderer durch
Zeichnen: von Höhlenzeichnungen bis Giaco-
metti, von Cézanne bis Brancusi. Zeichnungen
sind stets Hinweis auf die Denkweise der
Künstler. Ich kann kein künstlerisches Werk
aus dem Stehgreif nennen, das diesen Namen
verdient, in dem der Zeichnung nicht eine
Schlüsselposition zukäme. Wenn ich von

Zeichnung spreche, dann meine ich nicht eine
Kategorie, etwa zur Unterscheidung zur Male-
rei oder zur Bildhauerei. Es gibt Zeichnen in
der Zeichnung, wie es Zeichnen in der Malerei
und in der Bildhauerei gibt. Für die Zeichnun-
gen Brancusis interessiere ich mich nicht.
Mich interessiert aber, wie er in der Bildhau-
erei ‹zeichnet›. Wie er z. B. ein Volumen an
einer Kante abschneidet, das ist Zeichnung,
oder wie er eine Form herausschneidet, das ist
Zeichnung. Mittels Zeichnen wird deutlich,
wie jemand Material durch Maßstab, Anord-
nung und Ränder zusammenbringt.

Es gibt nur wenige Arbeiten, bei denen die
Analytik des Zeichnens nicht hilft, sie besser
zu verstehen, bei denen formale Strategien
keine Rolle spielen. Das trifft in besonderem
Maß auf die Malerei Newmans zu, auch wenn
Zeichnen dort struktureller Unterbau ist.

*D.S. Denkst Du genauso über Newmans
Bildhauerei?*

Das Problem bei Newmans Bildhauerei ist,
daß es ihr an Komplexität fehlt. ‹Broken
Obelisk› ist keine interessante Skulptur. Ich
sehe darin nichts weiter als ein ironisches
Bild, ein Spiel mit Ikonographie.

‹Zim Zum› könnte eine interessante
architektonische Idee sein, aber die Skulptur
ist es ohne Gewicht. Heute morgen ging ich
hier im Museum durch ‹Zim Zum›. Die
beiden spanischen Wände nehmen den
Außenraum nicht auf, innen bilden sie eine
Einbahnstraße, wegen ihres Anfangs und

drawing as a discipline different from that of painting and sculpture. There is the drawing of drawing and there is drawing in painting, as there is drawing in sculpture. I am not interested in Brancusi's drawings. I am interested, however, in the way he draws within his sculpture. How he completes a volume on the edge is drawing, how he cuts a form is drawing. Drawing defines how one collects material through scale, placement, and edge.

There are very few works where the analysis of drawing does not help to complete their understanding, where one has to dispense with formal investigations, where formal strategies evaporate. This is particularly true for Barnett Newman's paintings, even though drawing is their structural underpinning.

D.S. Do you feel that about Newman's sculpture as well?

The problem with Newman's sculpture is that it lacks complexity. The 'Broken Obelisk' is not an interesting sculpture. I see it as nothing more than an ironic image, a play on iconograhy. 'Zim Zum' might be an interesting architectural idea, but as sculpture it does not resonate. This morning I walked through 'Zim Zum' in the Gallery. The two folding screens do not collect the space on the outside, and on the inside, they create a onedirectional path with a beginning and an end, like a corridor. The zigzag walls do not hold a volume, nor do they define a mass. Space just floats through.

I was late to see Newman, and I probably would not have been engaged with his work if he had not come to see 'Strike' several times in 1971. 'Strike' is a freestanding steel plate, one inch thick, eight feet high, twenty-four feet long, placed into and held upright by the corner of the room. It cuts the corner into two juxtaposed volumes.

Some of Newman's sculptures, especially the 'Here' pieces, read as surrogates for his paintings. He seems to have literalised the zip with a thin vertical steel plate hoping that it would divide the space as the zips had divided the plane in his paintings. The fact of the matter is that the steel plates just stand there like objects. I think when Newman saw 'Strike' he realised that it was possible to cut space with sculpture as he had done in painting but was unable to do in the 'Here' group.

In Newman's paintings space and mass which are formed between the vertical divisions are experienced as you walk or scan the field. It is an experience that unfolds in time. Newman differentiates between the sense of time, that is the passage of literal time and the sensation of time, which is a physical experience of a given context. In this sense, Newman's invention was an enormous breakthrough and places him outside the parameters of traditional painting. In Cézanne, Picasso, de Kooning and Baselitz, content remains contained within the composition. In Newman content is inseparable from your sense of place and time. Without your

Endes eher noch einen Korridor. Die Zick-zackwände halten kein Volumen und definie-ren auch die Masse nicht. Der Raum fließt einfach spannungslos hindurch.

Ich sah Newmans Werk erst spät, und vielleicht hätte ich mich nie mit ihm befaßt, wäre er nicht mehrmals gekommen, um sich 1971 ‹Strike› anzusehen. ‹Strike› ist eine frei-stehende Stahlplatte, 2,5 cm dick, 2,44 m hoch, 7,22 m lang; sie steht aufrecht in der Ecke eines Raumes und wird von ihr gehal-ten. Sie zerteilt diese Ecke in zwei gegenein-ander gestellte Volumina.

Manche Skulpturen Newmans, insbeson-dere die ‹Here›-Stücke, kann man als Surro-gate seiner Bilder verstehen. Bei denen hat er scheinbar den ‹zip›, die einem Reißverschluß vergleichbare Linie, wörtlich genommen unter Verwendung einer dünnen vertikalen Stahl-platte, in der Hoffnung, daß sie den Raum genauso zerteilen würde, wie es die Linien tun.

Tatsächlich stehen die Stahlplatten wie Objekte herum. Ich glaube, Newman hat, als er ‹Strike› sah, gespürt, daß es möglich ist, Raum mittels einer Skulptur so zu zertrennen, wie er es in seiner Malerei geschafft hat; ohne daß ihm dies in der ‹Here›-Gruppe gelungen wäre.

In Newmans Bildern werden Raum und Masse, die sich zwischen den vertikalen Einteilungen bilden, erfahrbar gemacht, während man die Bildfläche durchwandert oder genau untersucht. Newman unterscheidet zwischen Zeitgefühl, einem tatsächlichen Zeit-fluß, und dem Gefühl für Zeit, einer physi-schen Erfahrung eines gegebenen Umfeldes. In dieser Hinsicht war Newmans Erfindung ein enormer Durchbruch, und sie stellt ihn außerhalb der Parameter traditioneller Male-rei. Bei Cézanne, Picasso, de Kooning und Baselitz bleibt Inhalt in Komposition erhalten. Bei Newman wird Inhalt untrennbar von eige-nem Gefühl für Ort und Zeit. Ohne eigene Erfahrung gibt es keinen Inhalt in einem Bild von Newman. Denkt man über ein Bild von Newman nach, erinnert man seine Erfahrung, nicht das Bild. Ich denke, daß das viel mit dem Begriff der Maßstäblichkeit zu tun hat.

Newman verwendete das Mittel des ‹zip›, um in seinen Bildern eine bilaterale ‹Symme-trie› zu schaffen, was bedeutet, daß er die Bildfläche in einer gewaltigen horizontalen und vertikalen Maßstäblichkeit öffnen konnte. Maßstäblichkeit ist unabhängig von Größe. Größe ist eine Funktion des Maßes, wohinge-gen Maßstäblichkeit eine Frage der Erfahrung ist, genauso wie Masse, Ort und Einbezogen-heit in den Bildern Newmans.

Newmans Bilder öffnen sich einem sehr vielschichtigen Wahrnehmungsverständnis. Möglicherweise ist die vertikale Bildfläche im Verhältnis zur horizontalen dafür entschei-dend, wie wir Zeit, Raum und Ort wahrneh-men und verstehen; daß er etwas berührt hat, was damit zu tun hat, wie wir uns bewegen; es könnte sein, daß der ‹zip›, der die Koordinaten der Bildfläche festlegt — oben, unten, rechts, links — seine Entsprechung in der vertikalen Achse unseres Körpers findet.

experience there is no content in a Newman painting. When you reflect upon a Newman, you recall your experience, you don't recall the picture. I think a lot of it comes down to the issue of scale. Newman used the device of the zip to create a bilateral symmetry in his paintings, which meant that he could open the field to tremendous horizontal and vertical scale. Scale is independent from size. Size is a function of measure whereas scale is a question of experience as is mass, place, and presence in Newman's paintings.

Newman's paintings are open to a very complex perceptual understanding. It could be that the vertical in relation to the horizontal field is fundamental to how we perceive and understand time, place and space; that he touched upon something that has to do with how we move and how we think when we move; it could be that the zip which sets up the coordinates of the field, top, bottom, right, left, corresponds to the vertical axis of our body.

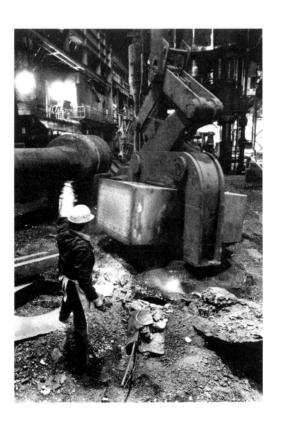

Scatter Piece
1967
7.62 x 7.62 m
New York

Ill. p./Abb. S. 28
Splashing
1968
46 cm x 7.92 m
New York

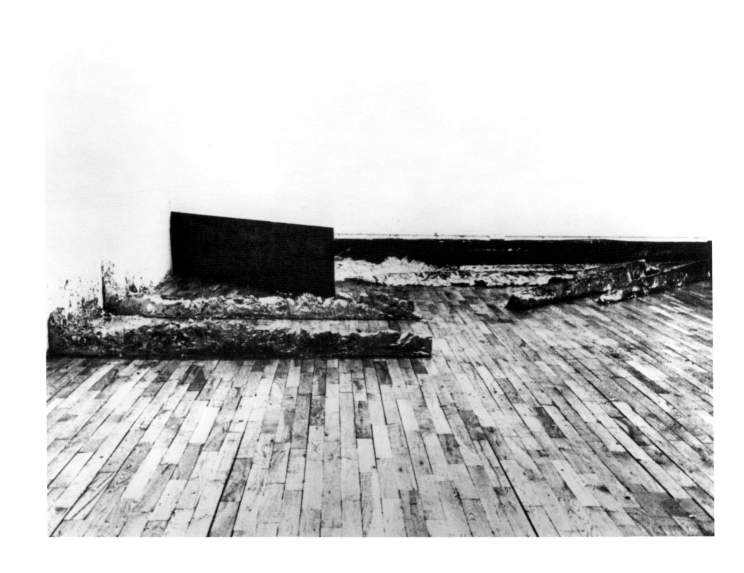

Splash Piece: Casting
1969/70
48 cm x 2.74 x 4.50 m
New York

30

Casting
1969
10 cm x 7.62 x 4.60 m
New York

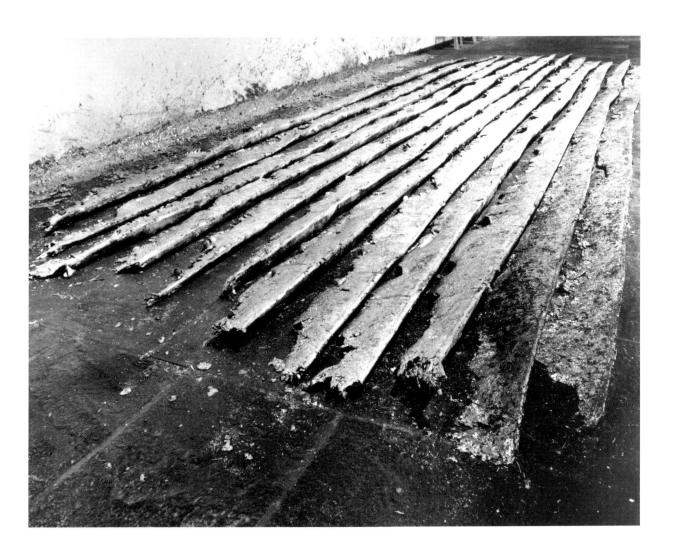

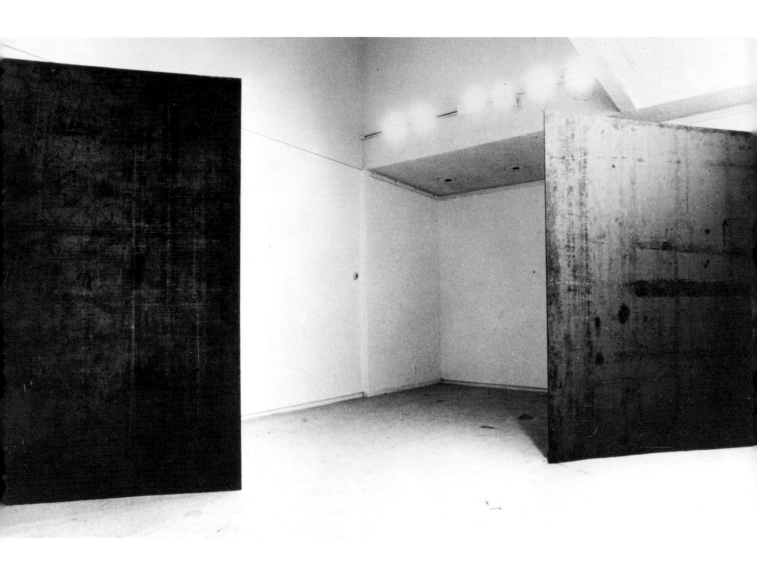

Davidson Gate
1969/70
2 plates each/Platten je
2.68 x 2.68 m x 2 cm
Ottawa

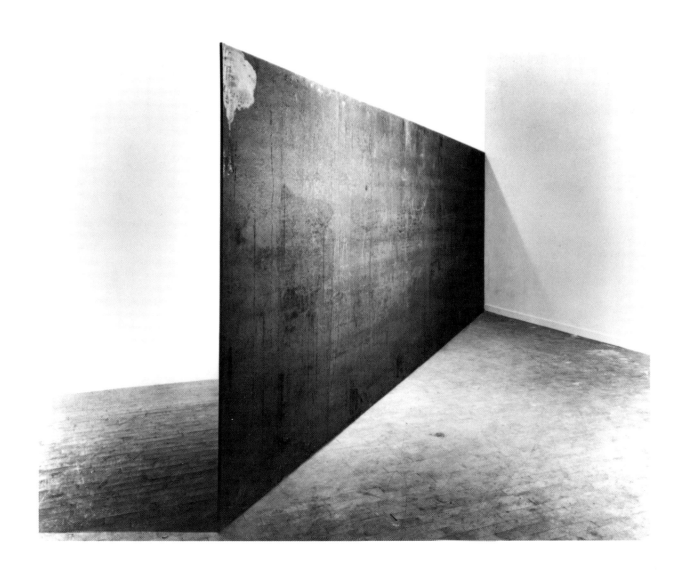

Strike
1969/71
2.44 x 7.32 m x 2 cm
New York

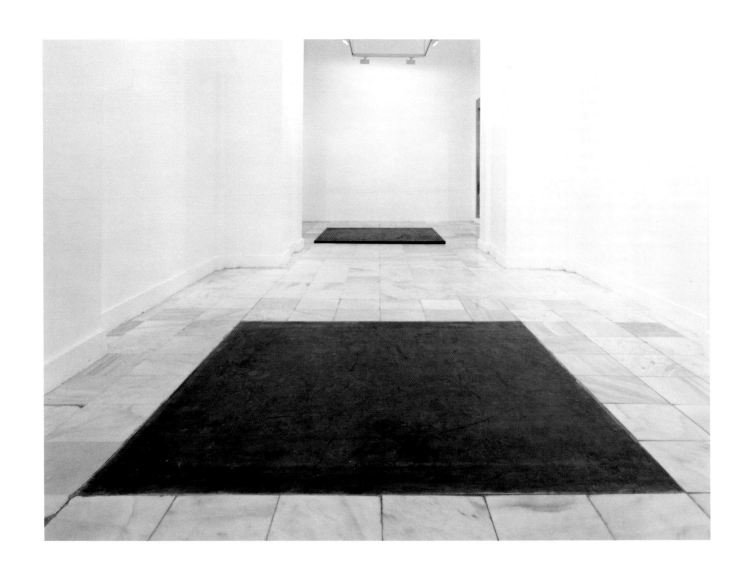

In-On II
1972/92
2 plates each/Platten je
2.40 x 2.40 m x 5 cm
Madrid

34

Circuit
1972
4 plates each/Platten je
2.44 x 7.31 m x 2 cm
Kassel

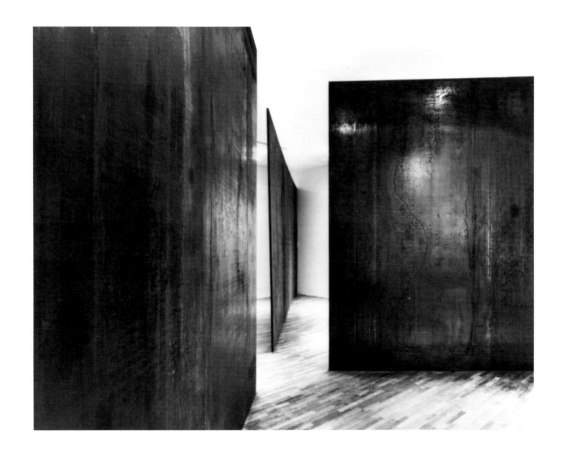

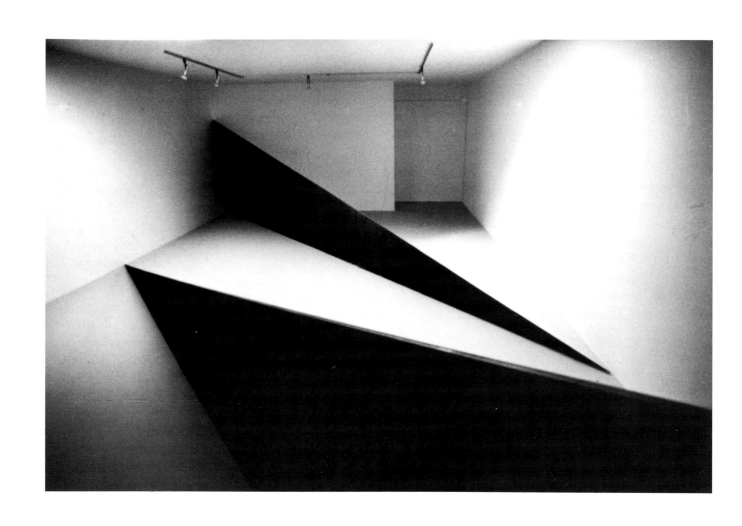

Twins: To Tony and Mary Edna
1972
2 plates each/Platten je
2.44 x 12.80 m x 2 cm
Los Angeles

P.S.1
1976
2 channels each/Kanäle je
5 x 13 cm x 9.14 m
New York

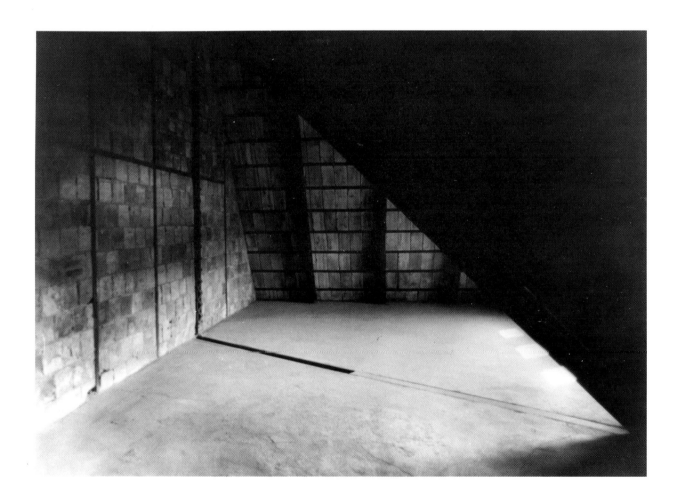

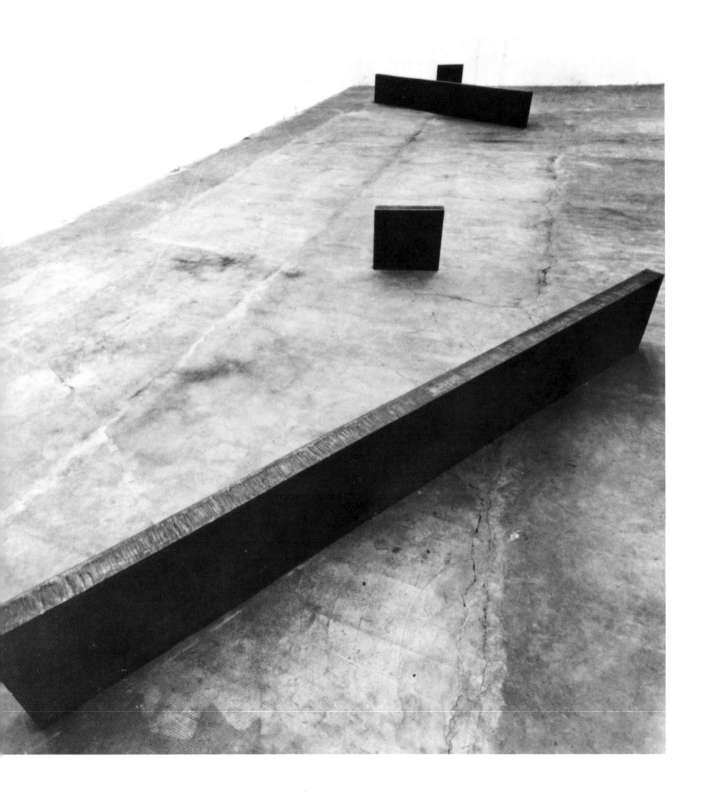

Delineator
1974
2 plates each/Platten je
2 cm x 3.04 x 7.92 m
Los Angeles

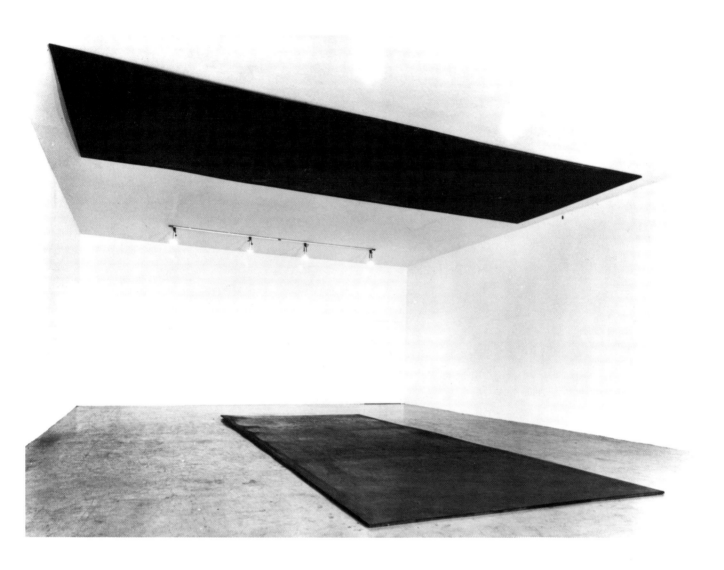

Equal Parallel and Right Angle Elevations
1973
4 elements/Elemente
2 elements each/Elemente je
61 cm x 4.60 m x 13 cm
61 x 69 x 13 cm
Milano

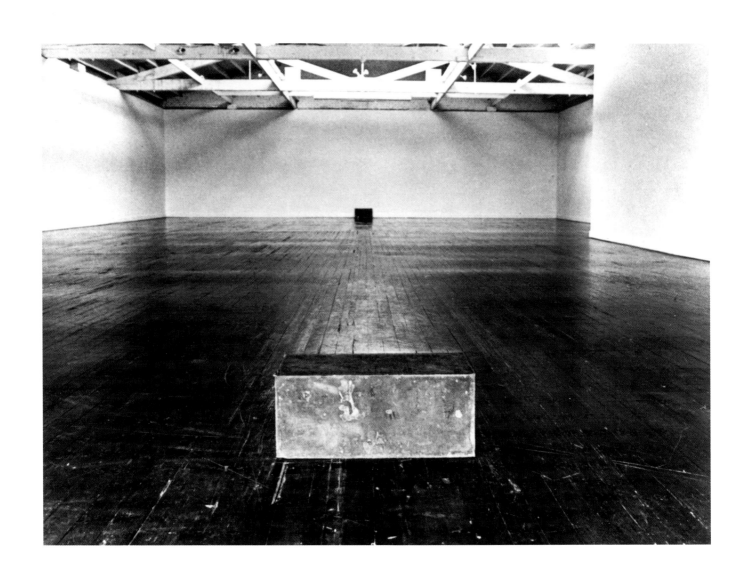

Unequal Elevations
1975
2 blocks/Blöcke
30.5 x 61 x 30.5 cm
25.5 x 61 x 30.5 cm
New York

42

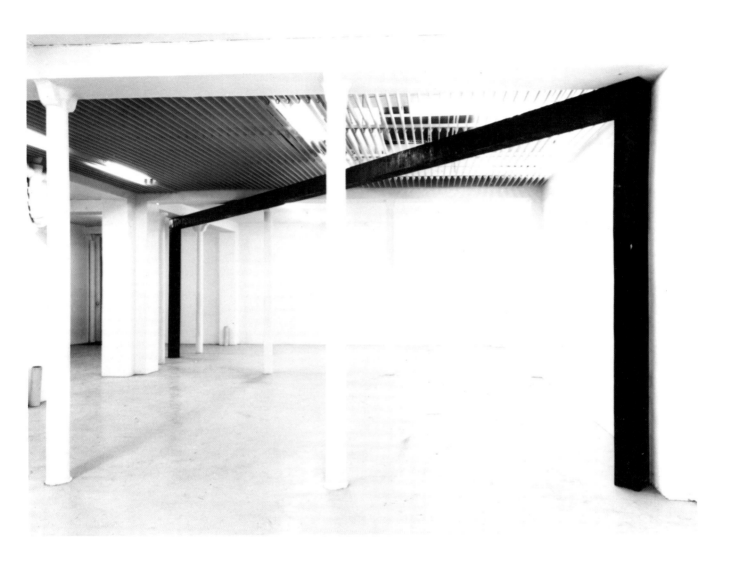

Span: for Alexander and Gilbert
1977
Overall/gesamt
3.02 x 11.04 m x 20 cm
Paris

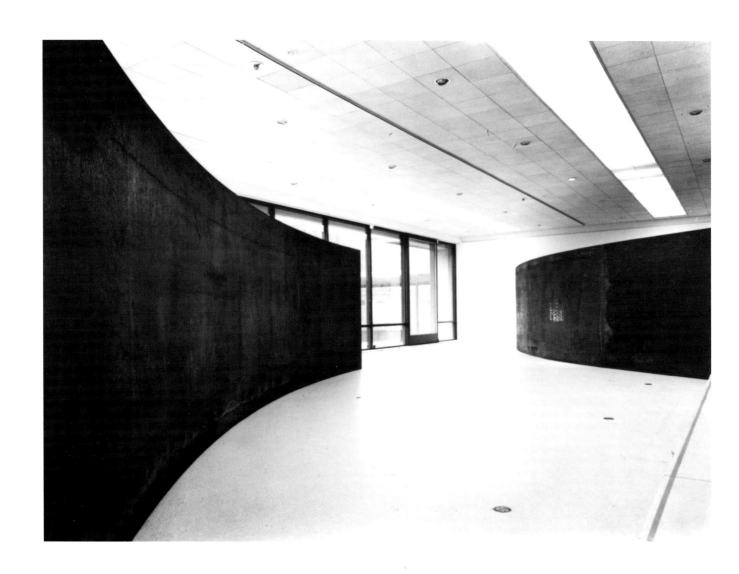

Waxing Arcs
1980
2 plates each/Platten je
3.00 x 12.29 m x 2 cm
Rotterdam

44

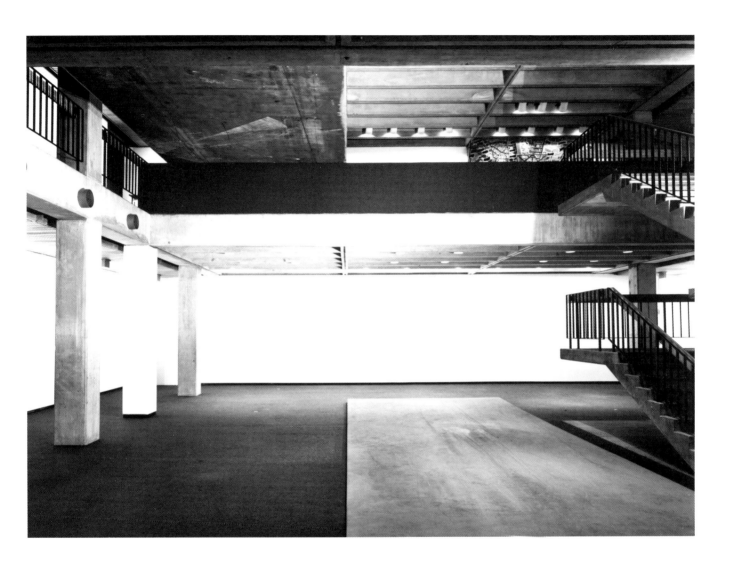

Elevator
1980
2 plates each/Platten je
6 cm x 3.66 x 12.32 m
New York

Slice
1980
3.04 x 37.95 m x 5 cm
New York

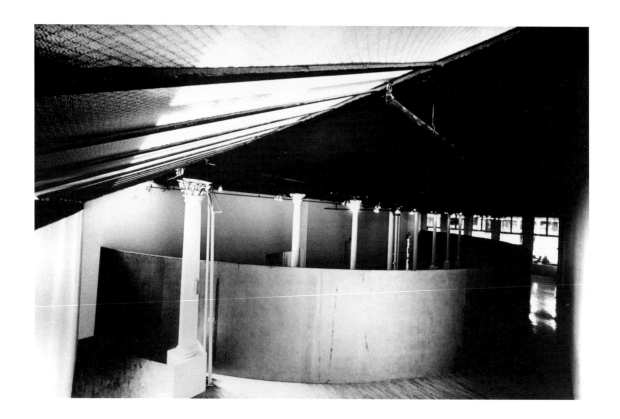

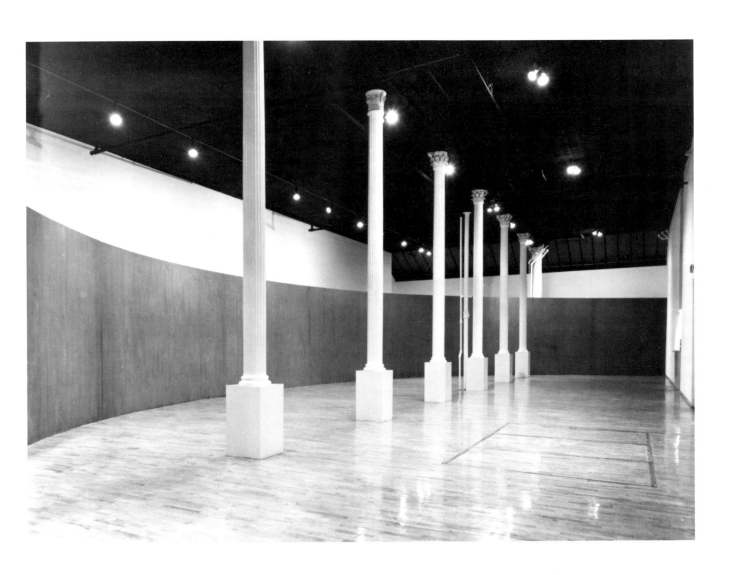

Wall to Wall
1983
8 plates each/Platten je
1.37 x 1.37 m x 5 cm
Overall/gesamt
1.37 x 10.98 m x 5 cm
Tokyo

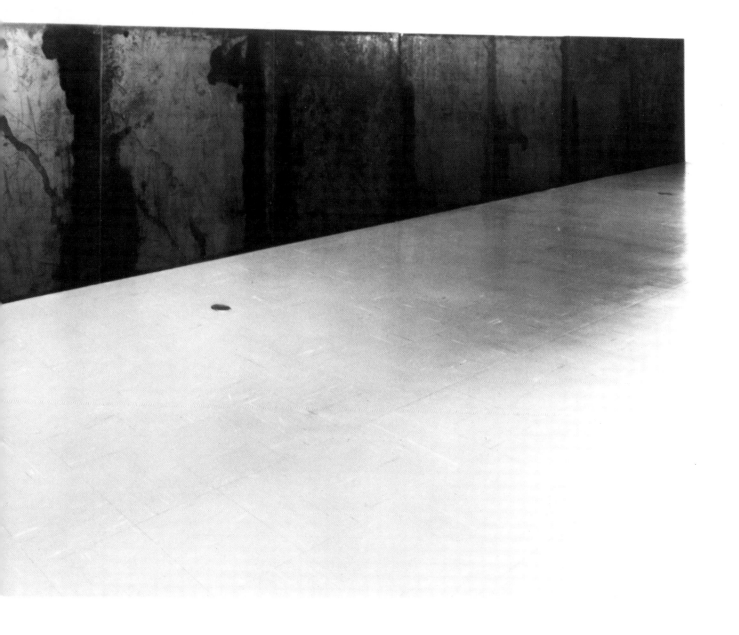

Equal Parallel Elevation
Guernica-Bengazi
1985
4 blocks/Blöcke
2 blocks each/Blöcke je
148.5 x 145.5 x 24 cm
148.5 x 500 x 24 cm
Madrid

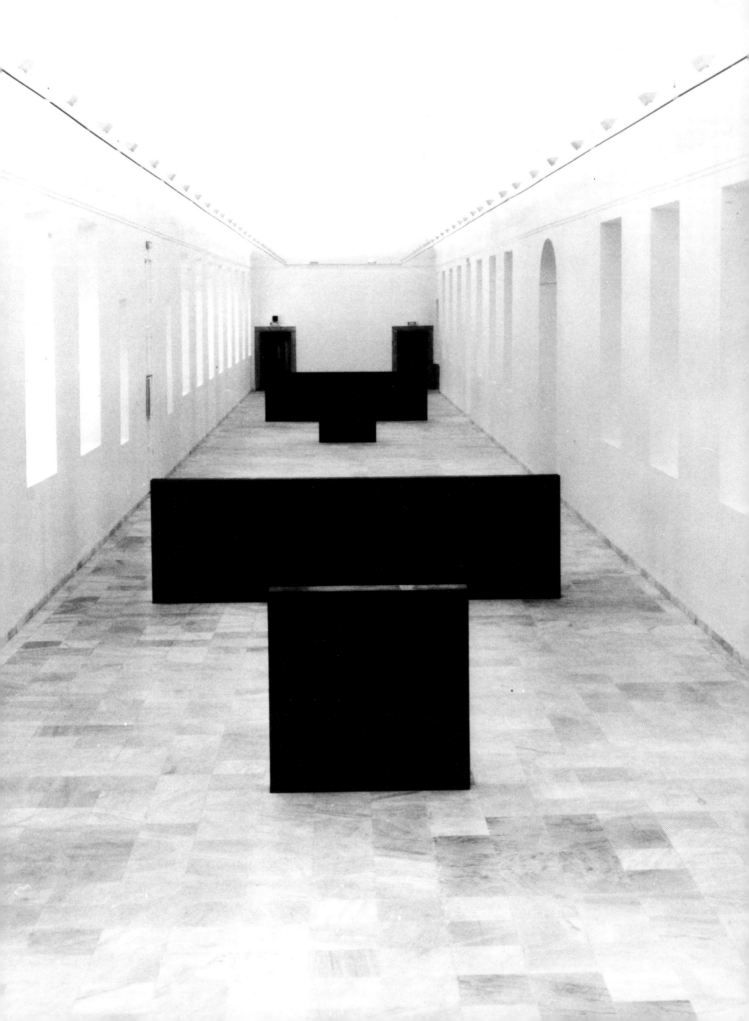

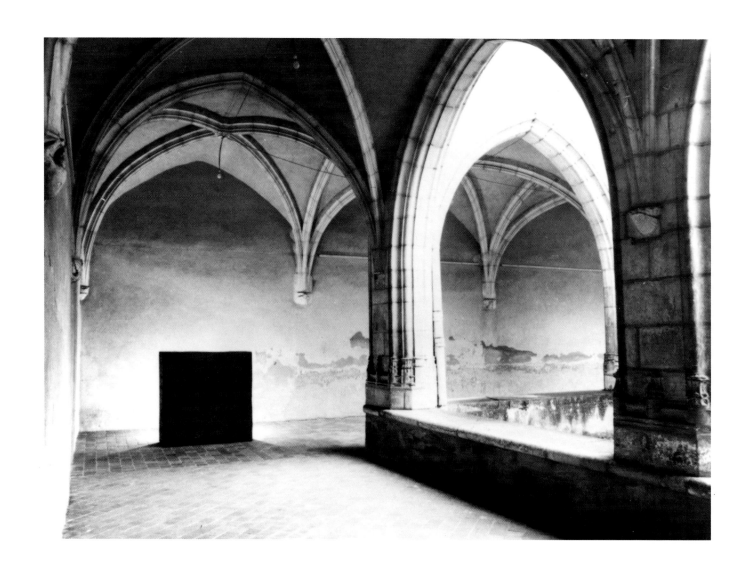

Marguerite and Philibert
1985
2 blocks/Blöcke
1.40 x 1.40 m x 53 cm
1.24 x 1.24 m x 53 cm
Bourg-en-Bresse

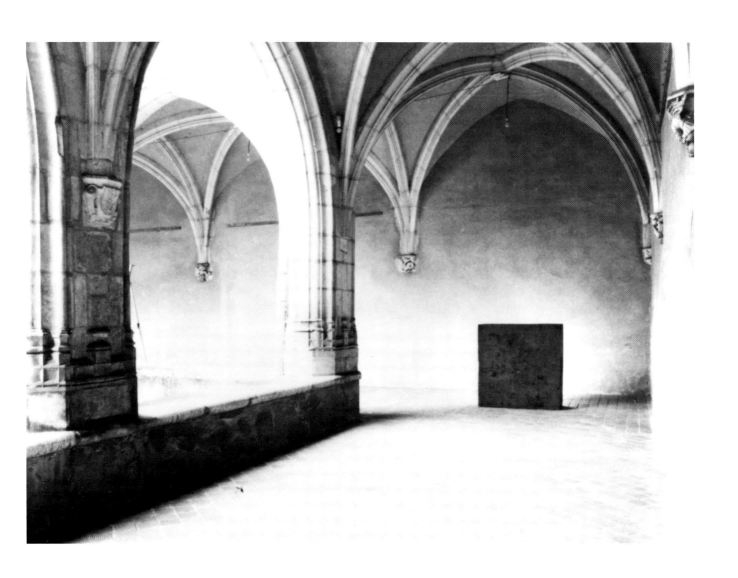

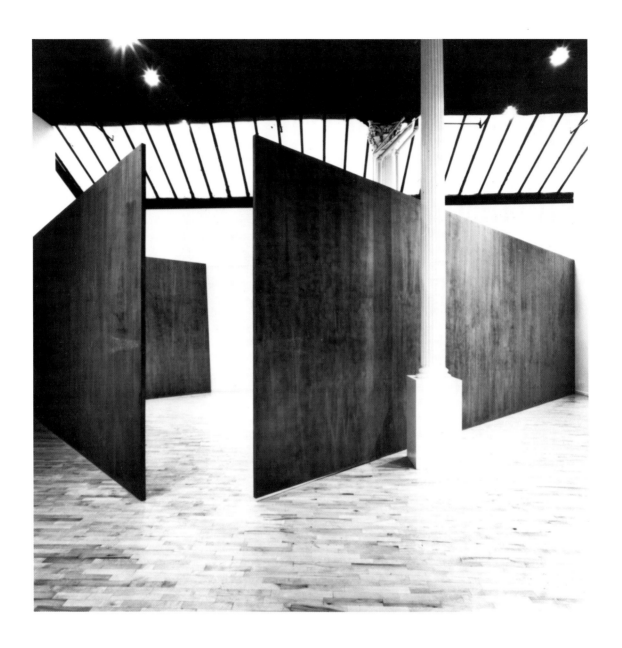

Sacco and Vanzetti
1986
3 plates/Platten
3.05 x 9.14 m x 4 cm
3.05 x 5.49 m x 4 cm
3.05 x 3.66 m x 4 cm
New York

Spiral Sections
1986/87
4 curved plates/Kurven
Overall/gesamt
30.02 x 26.21 m x 2 cm
Kassel

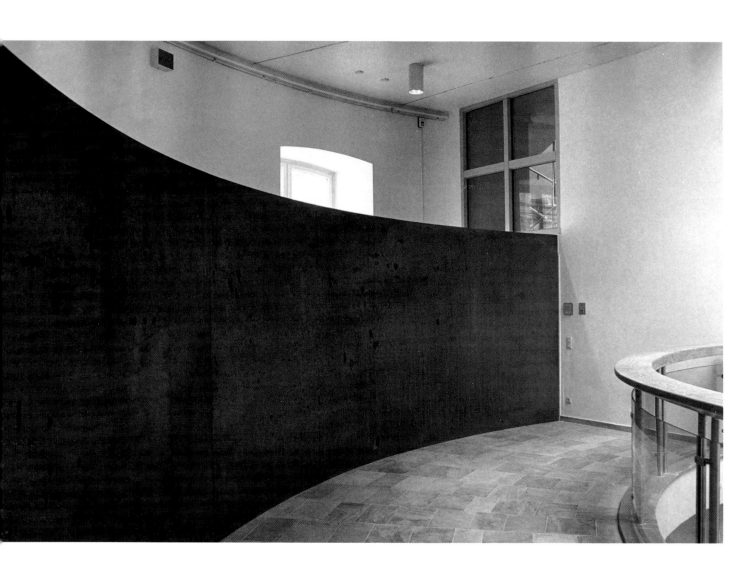

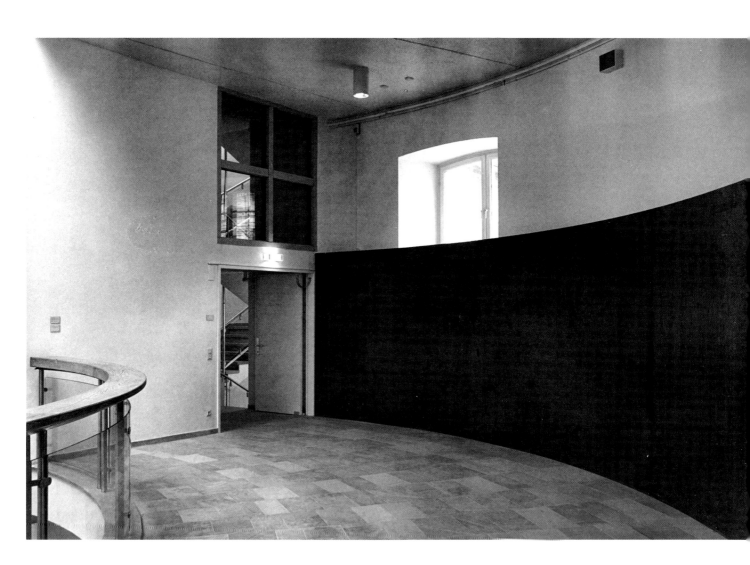

Vise
1987
2 plates each/Platten je
1.50 x 1.50 m x 20 cm
München

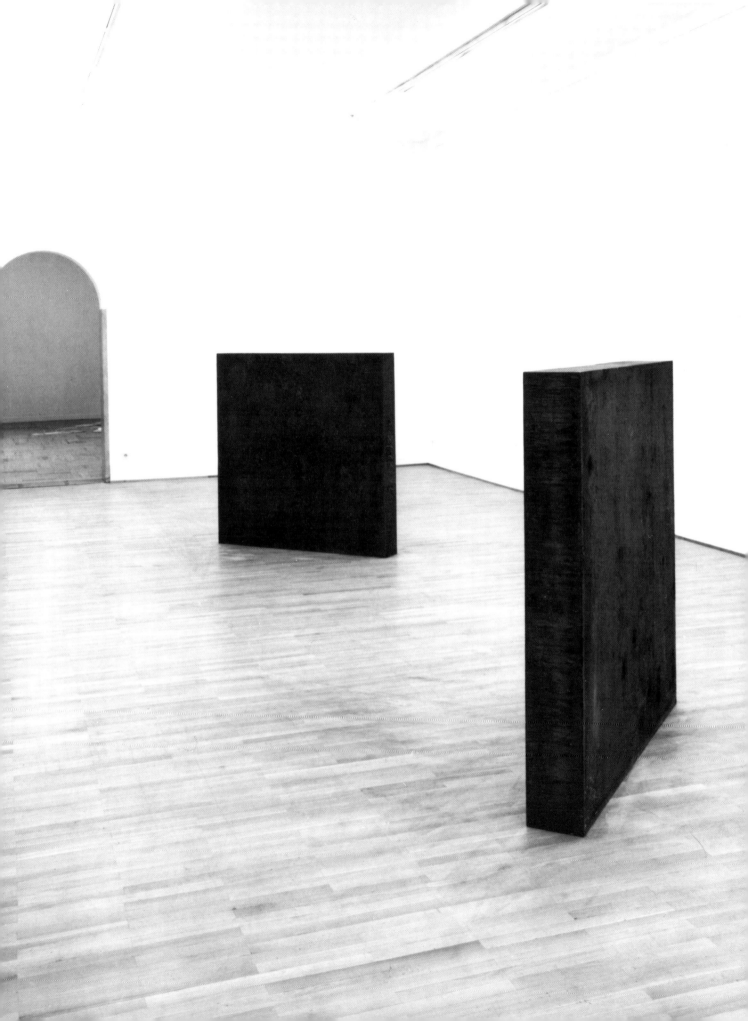

Cornered
1987
2 plates/Platten
4.27 x 8.23 m x 5 cm
4.27 x 5.10 m x 5 cm
New York

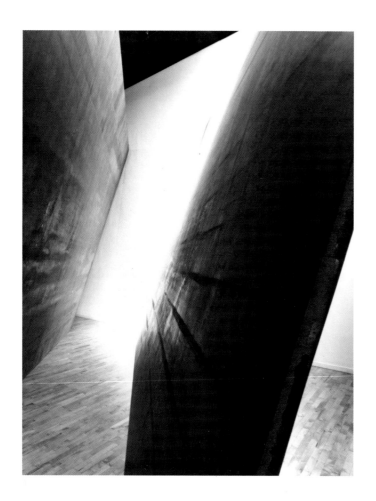

Gate
1987
4 bars/Balken
2 verticals each/Stützen je
33 x 33 x 30 cm
2 horizontals/Querbalken
33 x 33 cm x 5.23 m
33 x 33 cm x 4.49 m
München

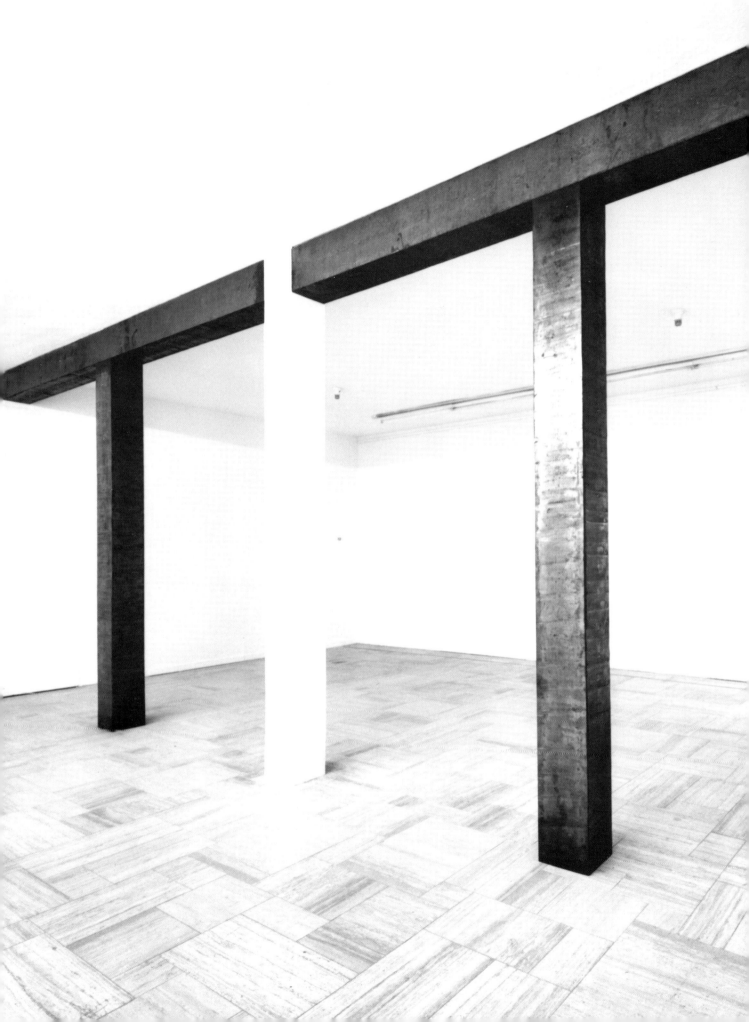

Opposite Corners Bisected
1987
2 plates each/Platten je
2.41 x 7.30 m x 2 cm
München

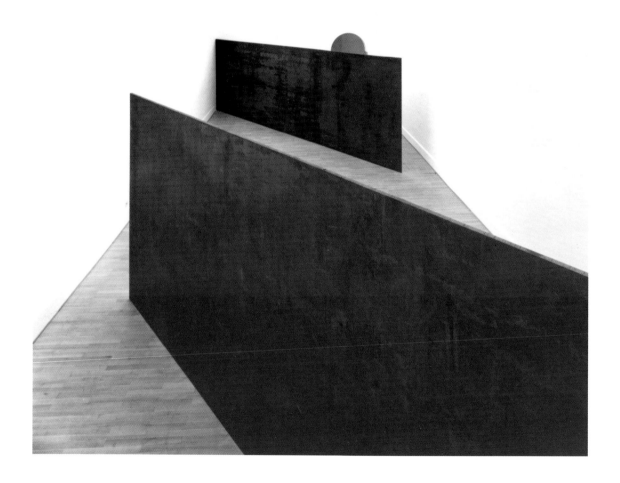

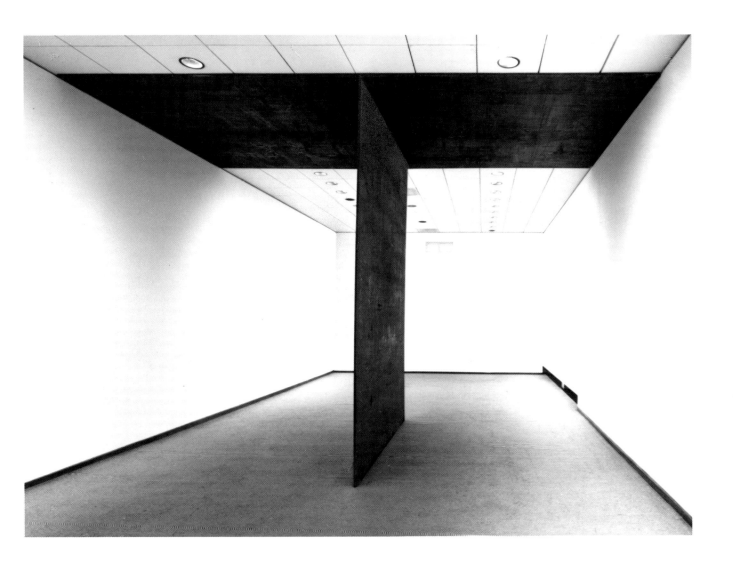

Timber
1988
2 plates/Platten
4.00 x 2.99 m x 2 cm
2.99 x 6.04 m x 2 cm
Berlin

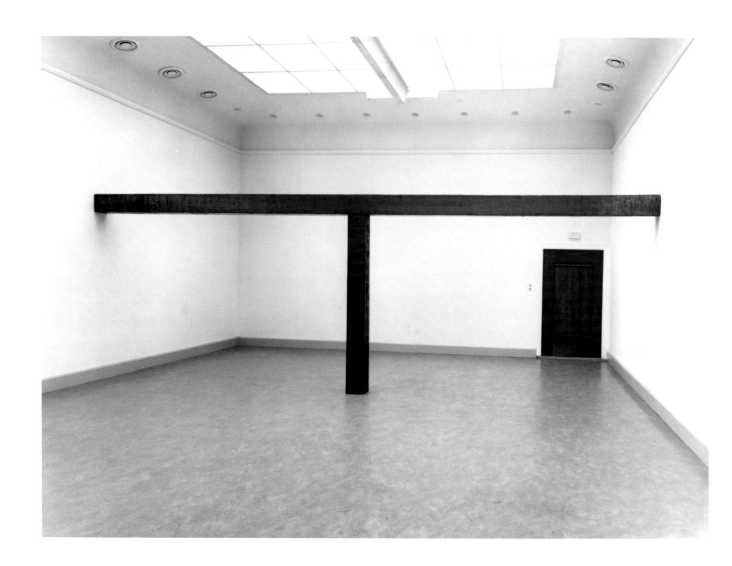

T-Junction
1988
2 bars/Balken
vertical/Stütze
25 x 25 cm x 2.38 m
horizontal/Querbalken
2.64 x 7.87 m x 25 cm
Eindhoven

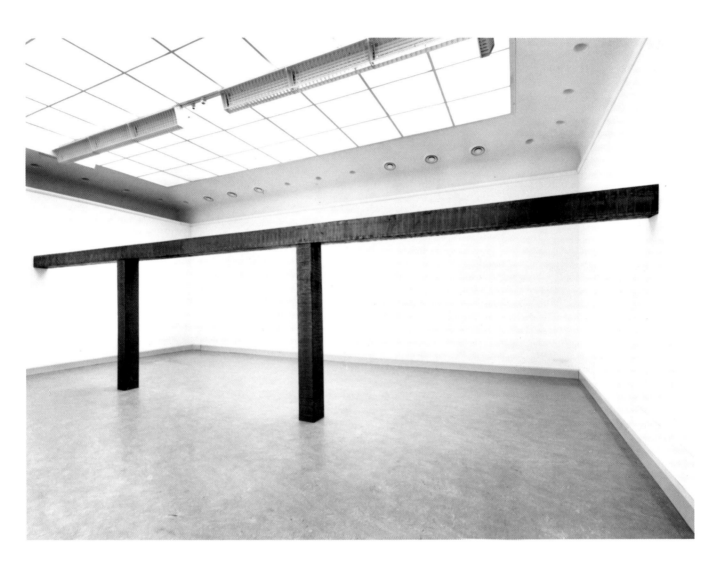

Maillart
1988
3 bars/Balken
2 verticals each/Stützen je
25 x 25 cm x 2.38 m
1 horizontal/Querbalken
25 x 25 cm x 11.23 m
Eindhoven

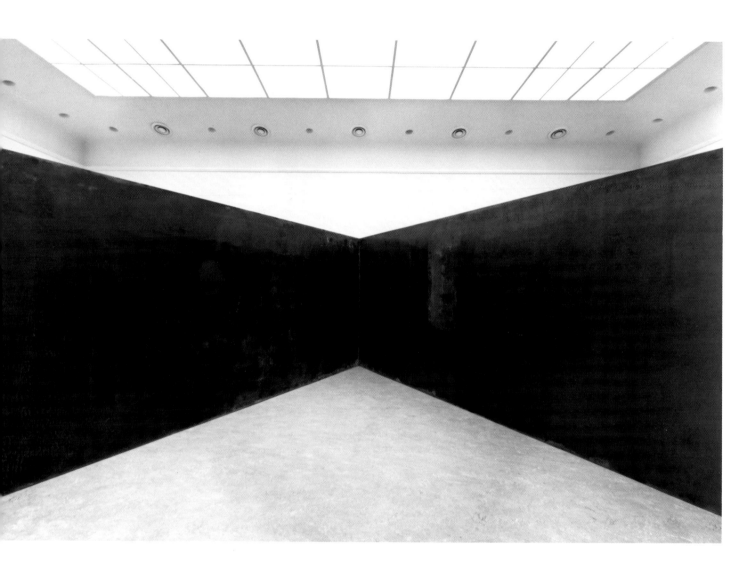

Sub Tend 60°
1988
2 plates each/Platten je
2.69 x 7.59 m x 2 cm
Eindhoven

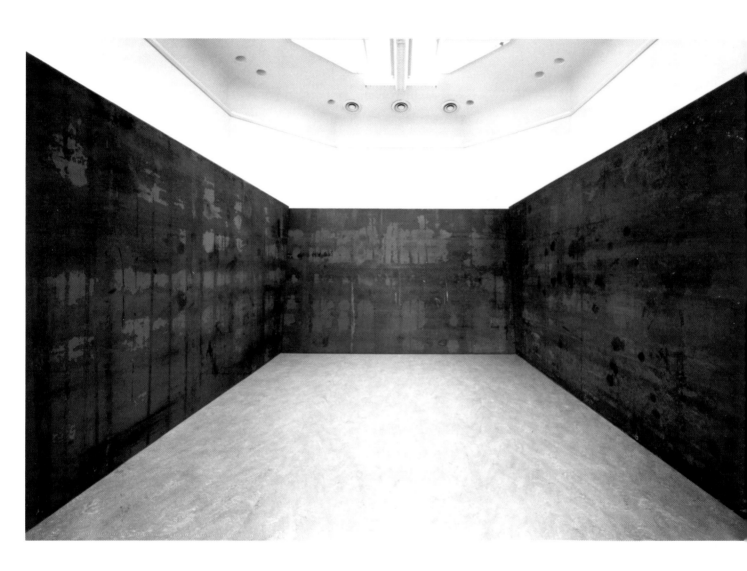

Chamber
1988
3 plates/Platten
2 plates each/Platten je 2.69 x 6.19 m x 2 cm
1 plate/Platte 2.69 x 4.19 m x 2 cm
Eindhoven

Stacks
1989
2 elements each/Elemente je
2.36 x 2.43 m x 25 cm
New Haven

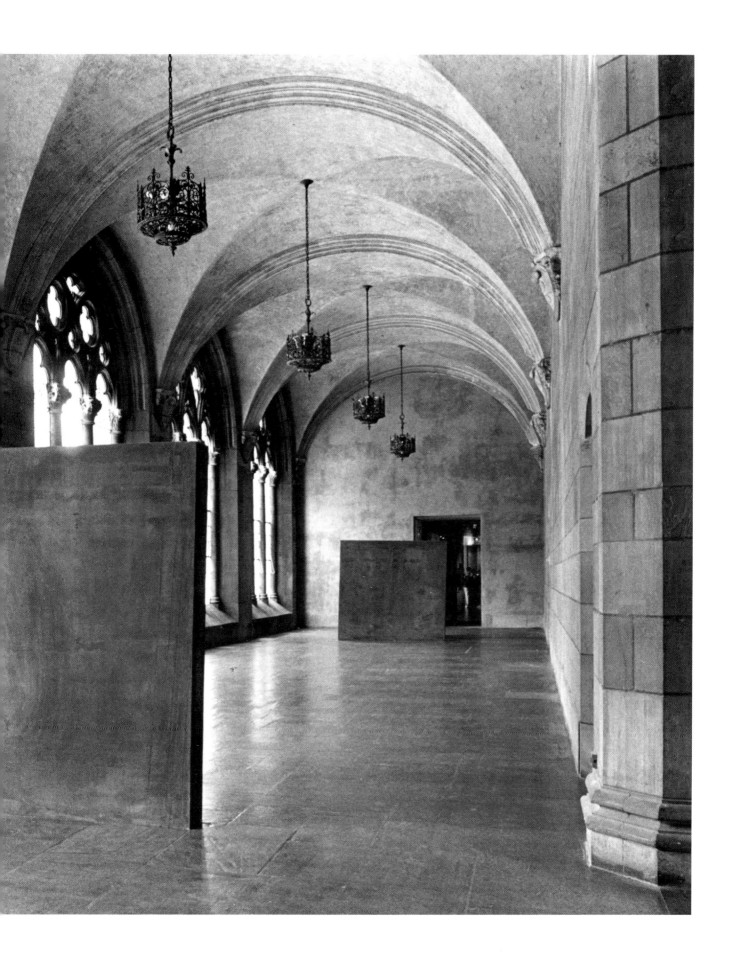

The Hours of the Day
1990
4 plates/Platten
1.82 x 2.08 m x 15 cm
1.67 x 5.12 m x 15 cm
1.52 x 5.12 m x 15 cm
1.37 x 5.12 m x 15 cm
Zürich

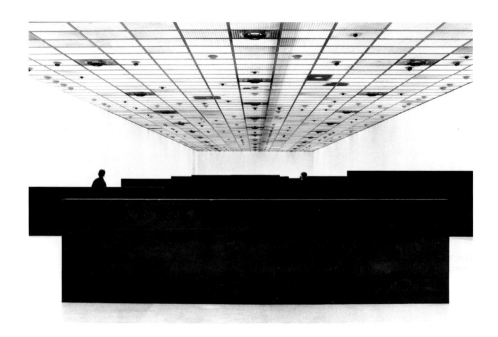

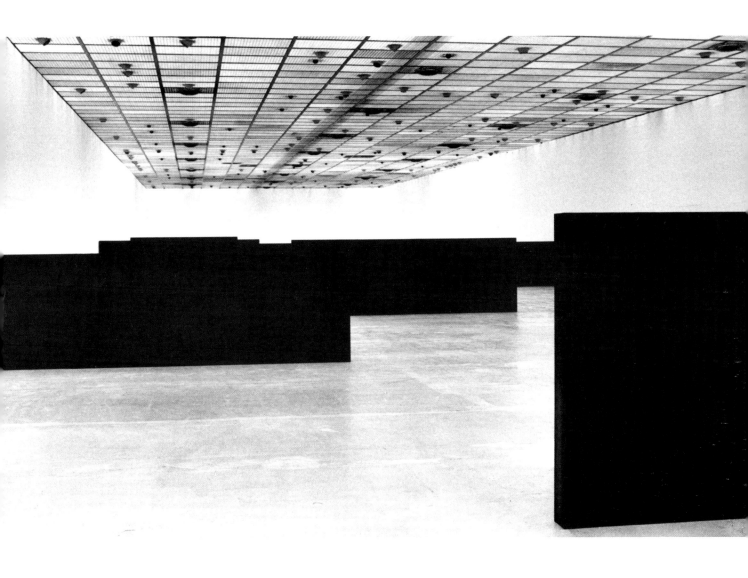

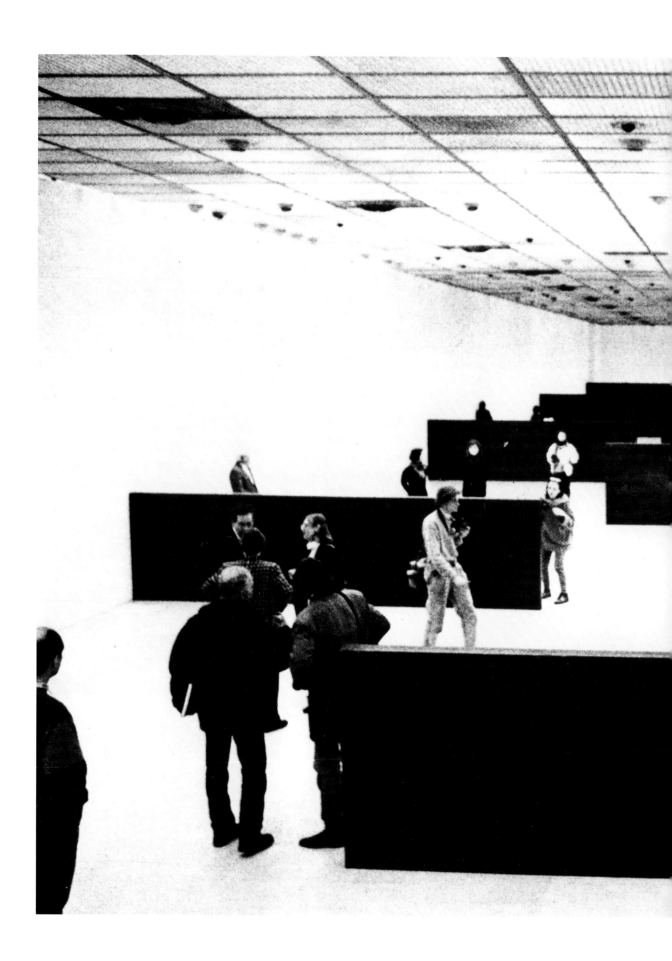

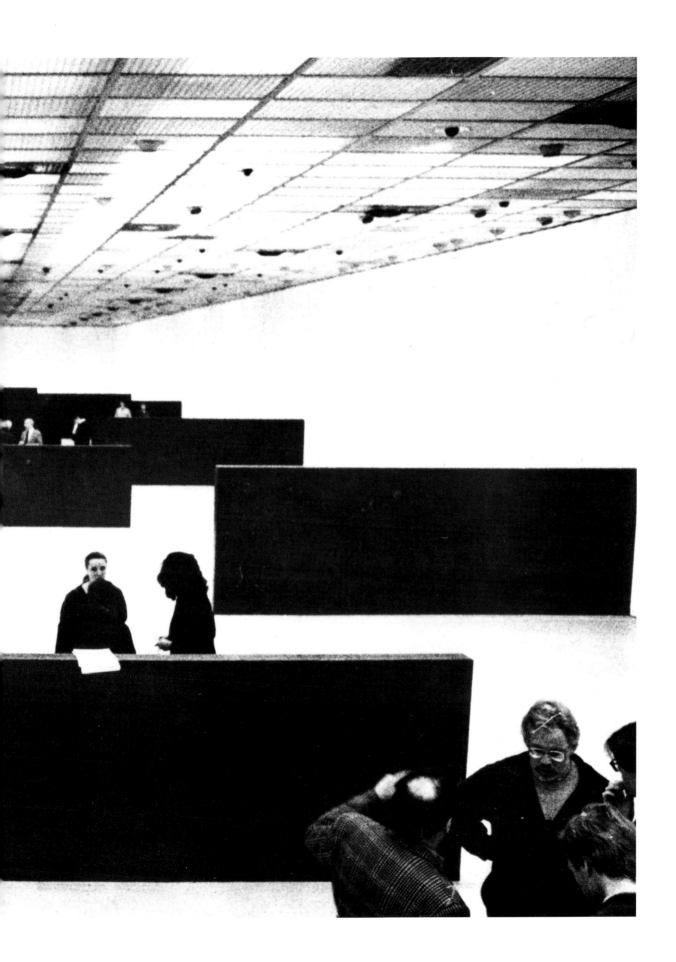

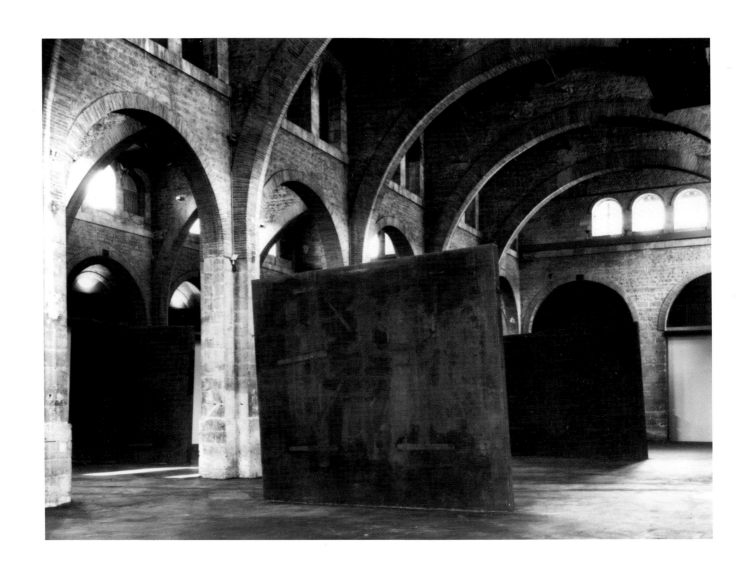

Threats of Hell
1990
3 plates each/Platten je
4.60 x 4.60 m x 25 cm
Bordeaux

Two Forged Rounds for Buster Keaton
1991
2 rounds each/Rundstücke je
1.62 x 2.26 m
New York

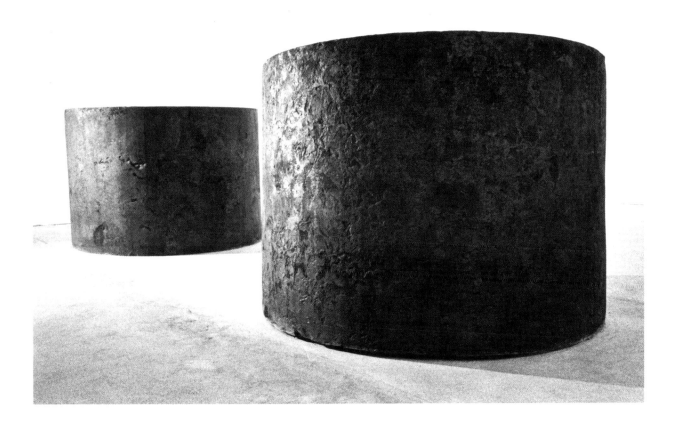

Splashing
1968/92
Length approx./Länge ca.
7.40 m
Tilburg

Splash Piece: Casting
1969/92
2 and 3 angles/2 und 3 Winkel
Approx./ca.
90 cm x 2.10 x 1.50 m
1.20 x 1.50 x 1.50 m
Tilburg

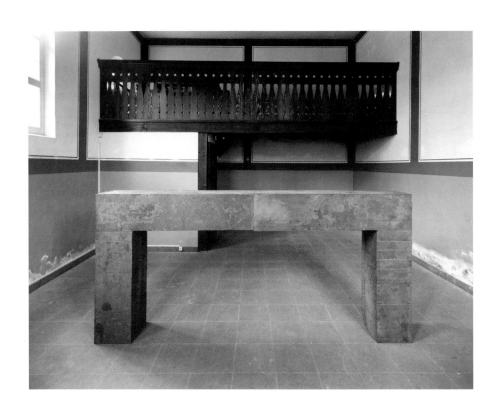

The Drowned and the Saved
1992
2 right angles elements each/Winkelelemente je
1.47 x 1.55 m x 35 cm
Stommeln

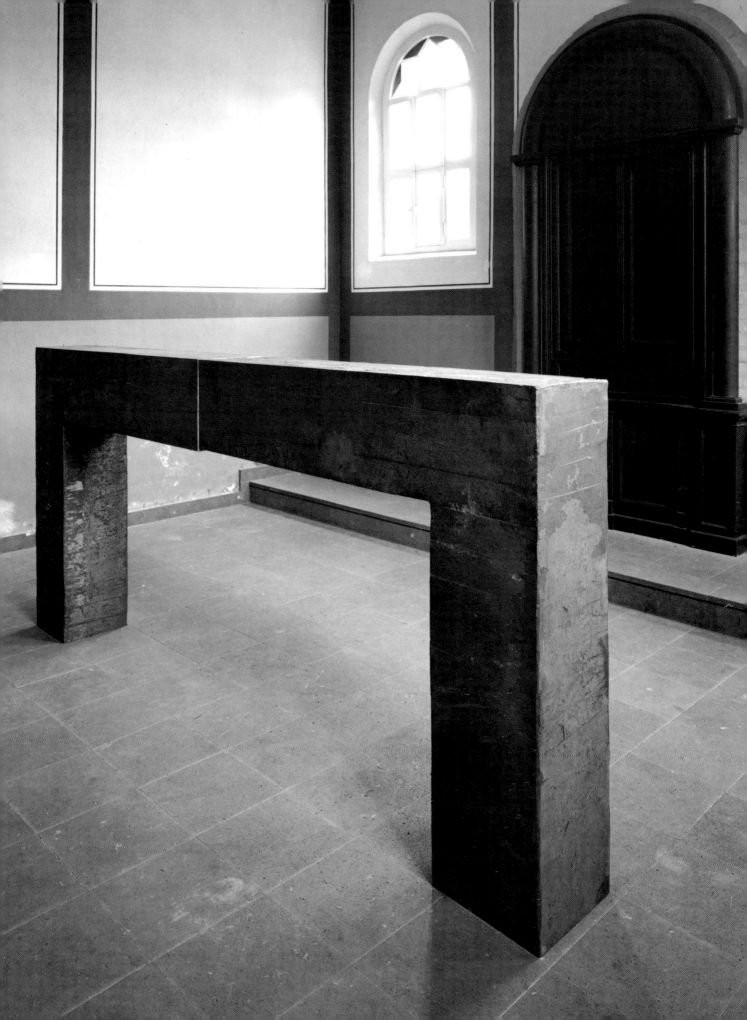

Running Arcs (For John Cage)
1992
3 conical elements each/konische Elemente je
4.00 x 17.00 m x 5 cm
Düsseldorf

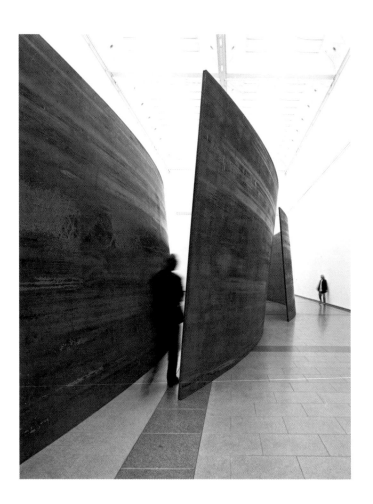

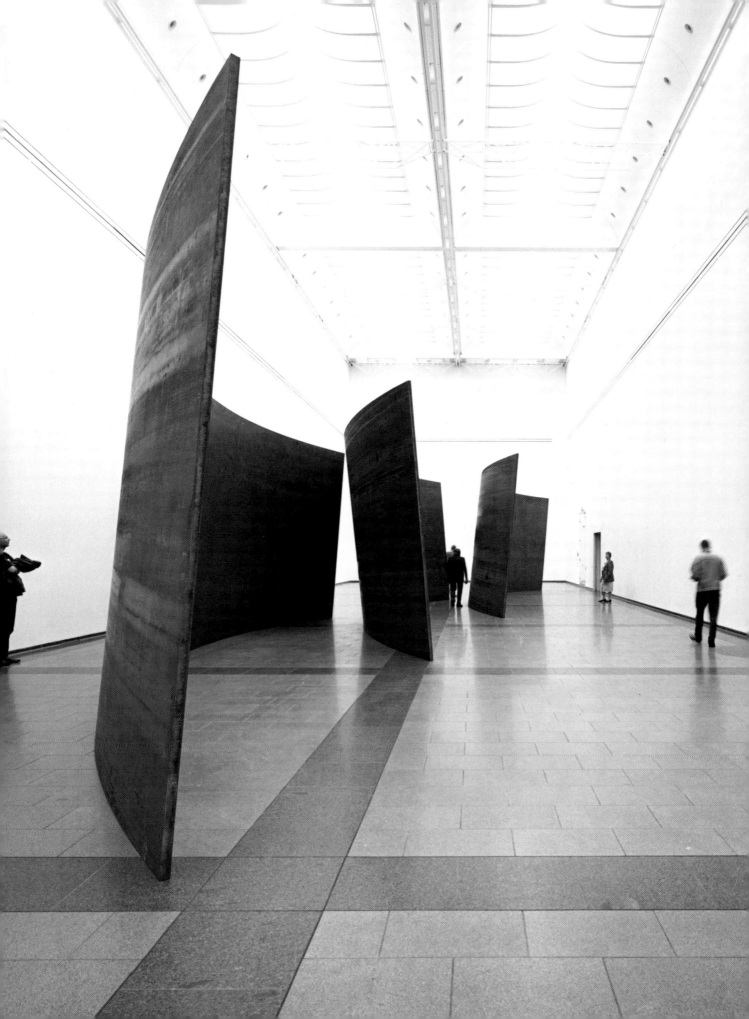

**Weight
and Measure**
1992
Installation

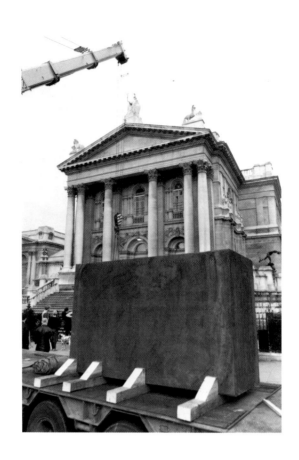

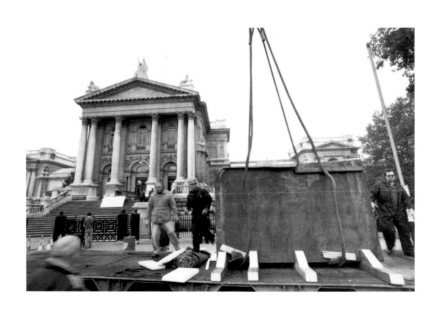

84

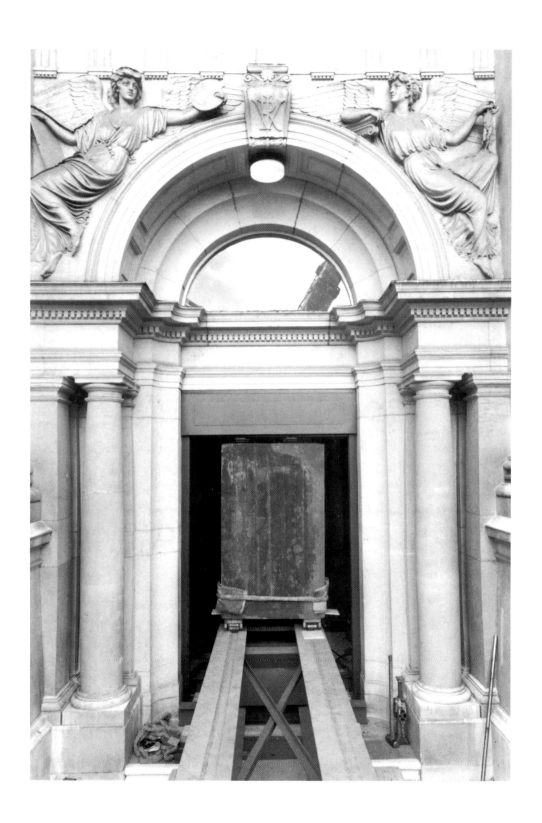

Weight and Measure
1992
2 blocks/Blöcke
1.73 x 1.04 x 2.75 m
1.52 x 1.04 x 2.75 m
London

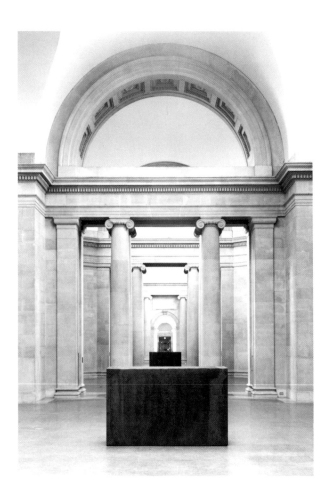

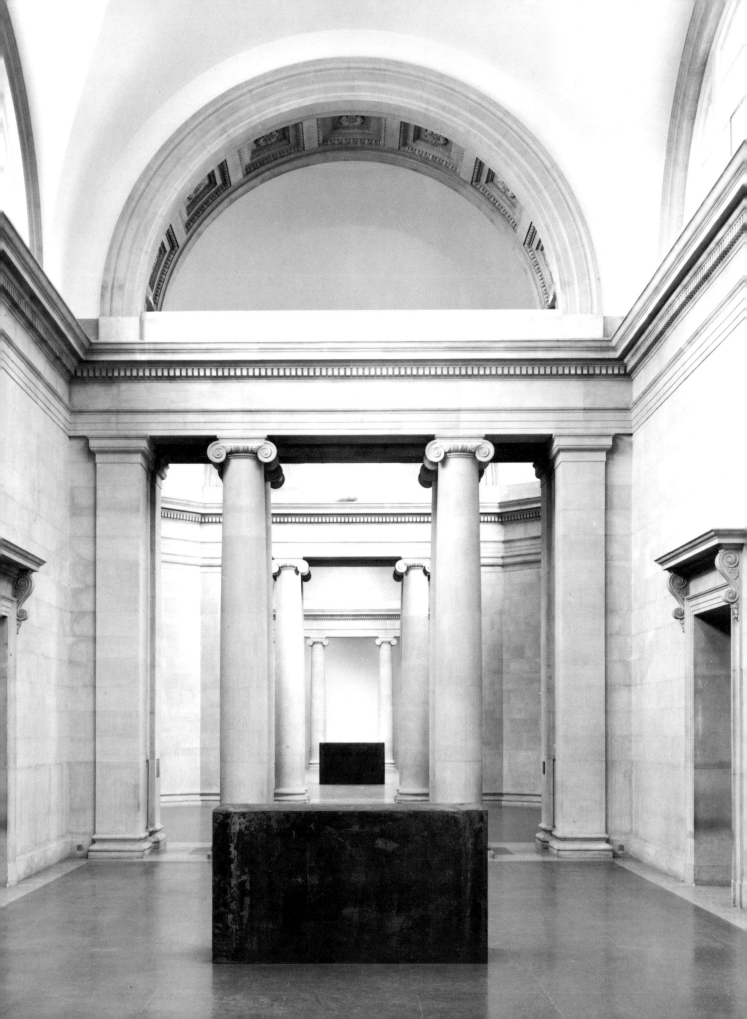

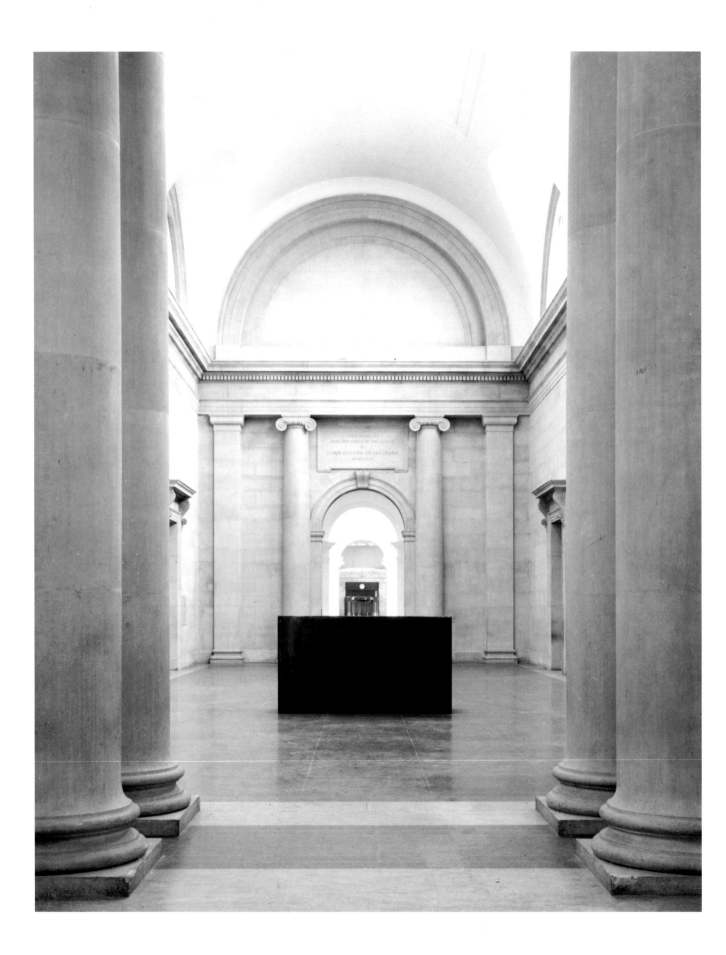

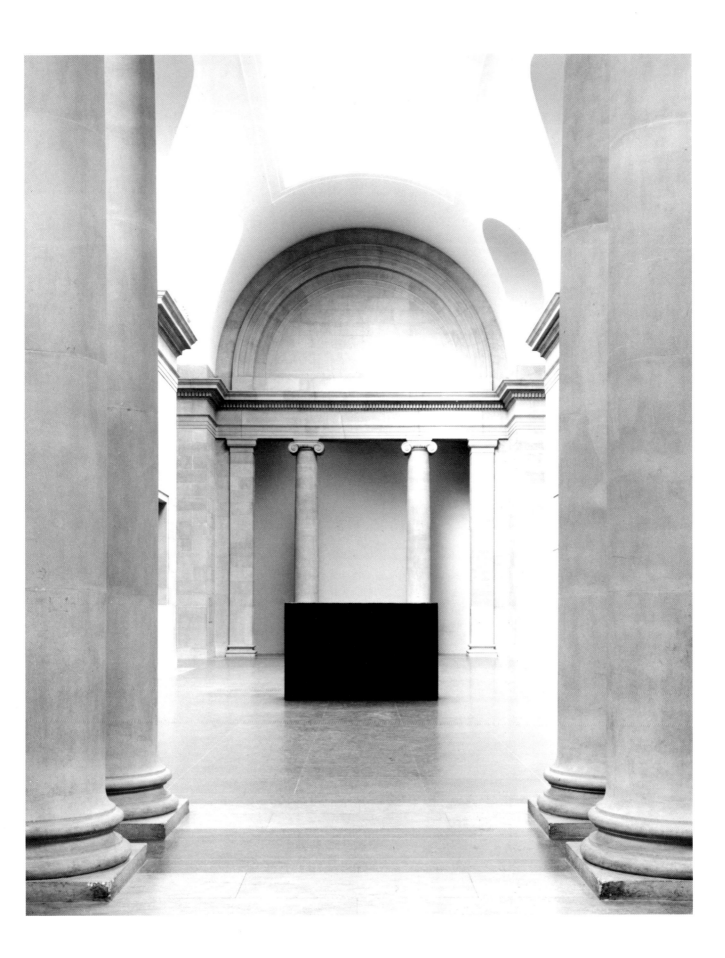

Site-Specific Indoor Installations: Sculpture

Verzeichnis der ortsbezogenen Innenraumskulpturen

Scatter Piece, 1967/68
Rubber latex/Latex-Gummi
25 x 25 ft / 7.62 x 7.62 m
Castelli Warehouse, NYC, for the
exhibition *Nine at Castelli*, 4-28 Dec. 1968
Castelli Warehouse, New York,
für die Ausstellung *Nine at Castelli*
Collection Donald Judd, Marfa, Texas
Illustrated page/Abbildung Seite 27

Splashing, 1968
Lead/Blei
18 in x 26 ft / 46 cm x 7.92 m
Castelli Warehouse, NYC, for the
exhibition *Nine at Castelli*, 4-28 Dec. 1968
Castelli Warehouse, New York,
für die Ausstellung *Nine at Castelli*
Illustrated pages/Abbildung Seite 28, 29

Casting, 1969
Lead/Blei
4 in x 25 x 15 ft / 10 cm x 7.62 x 4.60 m
Whitney Muscum of American Art, NYC,
for the exhibition *Anti-Illusion: Procedures/
Materials*, 19 May – 6 July 1969
Whitney Museum of American Art, New
York, für die Ausstellung *Anti-Illusion:
Procedures/Materials*
Illustrated page/Abbildung Seite 31

Splash, 1969
Lead/Blei
Approx./ca. 20 ft x 12 x 12 in
6.10 m x 30 x 30 cm

Installed outdoors in front of the Stedelijk
Museum, Amsterdam. Shown in conjunction
with the exhibition *Op Losse Schroeven,
situaties en cryptostructuren (Square Pegs in
Round Holes)*, 15 March – 27 April 1969
Installiert auf dem Vorplatz des Stedelijk
Museums, Amsterdam, in Verbindung mit
der Ausstellung *Op losse Schroeven, situaties en
cryptostructuren›*

Splashing with Four Molds, to Eva Hesse, 1969
Lead/Blei
30 x 30 x 30 ft 6 in / 9.14 x 9.14 x 9.23 m
Castelli Warehouse, NYC, for one-man
exhibition, 16 Dec. 1969 – 10 Jan. 1970
Castelli Warehouse, New York,
Einzelausstellung

Splash Piece: Casting, 1969/70
Lead/Blei
19 in x 9 x 14 ft 11 in
48 cm x 2.74 x 4.50 m
Jasper Johns' studio, NYC, 1970
Atelier von Jasper Johns, New York
Collection San Francisco Museum of
Modern Art
Gift/Schenkung: Jasper Johns
Illustrated page/Abbildung Seite 30

Davidson Gate, 1969/70
Hot rolled steel/Walzstahl
2 plates each/Platten je
8 x 8 ft x 1 in
2.68 x 2.68 m x 2 cm

Installed National Gallery of Canada,
Ottawa, 1970
Installiert National Gallery of Canada,
Ottawa
Collection National Gallery of Canada,
Ottawa
Gift/Schenkung: Mr and Mrs R. Davidson
Illustrated page/Abbildung Seite 32

Strike, 1969/71
Hot rolled steel/Walzstahl
8 x 24 ft x 1 in / 2.44 x 7.32 m x 2 cm
Installed Lo Guidice Gallery, NYC,
28 Nov. 1971 — 29 Jan. 1972
Installiert Lo Guidice Gallery, New York
Collection Solomon R. Guggenheim
Museum, NYC
Illustrated page/Abbildung Seite 33

Strike II, 1969/92
Hot rolled steel/Walzstahl
8 ft 10 in x 23 ft x 1 in / 2.70 x 7.20 m x 2 cm
Installed Museo Nacional Reina Sofia,
Madrid, for the exhibition
Richard Serra,
28 Jan. — 23 March 1992
Installiert im Museo Nacional Reina Sofia,
Madrid, für die Ausstellung *Richard Serra*

Circuit, 1972
Hot rolled steel/Walzstahl
4 plates each/Platten je
8 x 24 ft x 1 in
2.44 x 7.31 m x 2 cm
Installed Kassel for the exhibition
documenta 5,
30 June — 8 Oct. 1972
Installiert auf der *documenta 5,* Kassel
Illustrated pages/Abbildungen Seite 35-37

Circuit II, 1972/86
Hot rolled steel/Walzstahl
4 plates each/Platten je
10 x 20 ft x 2 in
3.05 x 6.10 m x 5 cm
Installed Museum of Modern Art, NYC, for
the exhibition *Richard Serra, Sculpture,*
27 Feb. — 19 May 1986
Installiert im Museum of Modern Art, New

York, für die Ausstellung *Richard Serra,
Sculpture*
Collection Museum of Modern Art, NYC

Circuit III, 1972/89
Hot rolled steel/Walzstahl
4 plates each/Platten je
11 ft 8 in x 26 ft 3 in x 1 $^1/_2$ in
3.55 x 8.00 m x 3.2 cm
Installed Situation Kunst — Für Max
Imdahl, Bochum, March 1989
Installiert in Situation Kunst — Für Max
Imdahl, Bochum
Collection/Kunstsammlungen der Ruhr-
Universität, Bochum

Untitled, 1972
Steel/Stahl
6 rods/Stäbe
2 rods each/Stäbe je
4 x 4 x 20 in / 10 x 10 x 50 cm
2 rods each/Stäbe je
4 x 4 in x 10 ft 1 in / 10 x 10 cm x 3.07 m
2 rods each/Stäbe je
3 x 3 in x 10 ft 1 in / 8 x 8 cm x 3.07 m
Installed Leo Castelli Gallery, NYC,
group exhibition, 30 Sept. — 21 Oct. 1972
Installiert in der Leo Castelli Gallery, New
York, für eine Gruppenausstellung

Twins: To Tony and Mary Edna, 1972
Hot rolled steel/Walzstahl
2 plates each/Platten je
8 x 42 ft x 1 in
2.44 x 12.80 m x 2 cm
A rectangular plate was cut in two identical
triangles which were installed in opposite
corners
Eine rechteckige Platte wurde in zwei gleiche
Dreiecke zerschnitten und in gegenüberlie-
genden Ecken plaziert
Installed Ace Gallery, Los Angeles, for the
exhibition *Richard Serra,*
17 Nov. — 31 Dec. 1972
Installiert in der Ace Gallery, Los Angeles,
für die Ausstellung *Richard Serra*
Collection Solomon R. Guggenheim
Museum, NYC
Illustrated page/Abbildung Seite 38

In-On, 1972/89
Steel/Stahl
2 plates each/Platten je
2 in x 10 x 10 ft / 5 cm x 3.04 x 3.04 m
Installed Ace Gallery, Los Angeles, for the
exhibition *The Innovators/Entering the
Sculpture*, 14 Sept. − 25 Nov. 1989
Installiert in der Ace Gallery, Los Angeles,
für die Ausstellung *The Innovators/Entering
the Sculpture*
Collection William Wilson, San Mateo,
California

In-On II, 1972/92
Hot rolled steel/Walzstahl
2 plates each/Platten je
7 ft 10 in x 7 ft 10 in x 2 in
2.40 x 2.40 m x 5 cm
Installed Museo National Reina Sofia,
Madrid, for the exhibition
Richard Serra, 29 Jan. − 23 March 1992
Installiert im Museo National Reina Sofia,
Madrid
Illustrated page/Abbildung Seite 34

Equal Parallel and Right Angle Elevations,
1973
Hot rolled steel/Walzstahl
4 elements/Elemente
2 elements each/Elemente je
24 in x 14 ft 9 in x 5 in
61 cm x 4.60 m x 13 cm
2 elements each/Elemente je
24 x 27 x 5 in / 61 x 69 x 13 cm
Installed Galleria Toselli, Milan, for the
exhibition *Richard Serra*, 1973
Installiert in der Galleria Toselli, Mailand,
für die Ausstellung *Richard Serra*
Private Collection
Illustrated page/Abbildung Seite 40

Delineator, 1974/75
Steel/Stahl
2 plates each/Platten je
1 in x 10 x 26 ft
2 cm x 3.04 x 7.92 m
Installed Ace Gallery, Los Angeles, for the
exhibition *Richard Serra: Delineator,*
July 1975 − Feb. 1976

Installiert in der Ace Gallery, Los Angeles,
für die Ausstellung *Richard Serra:
Delineator*
Illustrated page/Abbildung Seite 41

Delineator II, 1974/86
Steel/Stahl
2 plates each/Platten je
1 in x 10 x 20 ft / 2 cm x 3.04 x 6.08 m
Installed Museum of Modern Art, NYC, for
the exhibition *Richard Serra, Sculpture,*
27 Feb. − 19 May 1986
Installiert im Museum of Modern Art, New
York, für die Ausstellung *Richard Serra,
Sculpture*

Delineator III, 1974/88
Steel/Stahl
2 plates each/Platten je
1 in x 10 x 20 ft / 2 cm x 3.04 x 6.08 m
Installed Städtische Galerie im
Lenbachhaus, Munich, for the exhibition
Richard Serra: 7 Spaces − 7 Sculptures,
26 Nov. 1987 − 28 Feb. 1988
Installiert in der Städtischen Galerie im
Lenbachhaus, München, für die Ausstellung
Richard Serra: 7 Spaces − 7 Sculptures
Collection Städtische Galerie im
Lenbachhaus, München

P.S.1, 1976
Hot rolled steel/Walzstahl
2 channels each/Kanäle je
2 x 5 in x 30 ft / 5 x 13 cm x 9.14 m
Installed Institute for Art and Urban
Resources P.S. 1, Long Island City, NYC,
for the exhibition *Rooms,*
9 June − 26 June 1976
Installiert in dem Institute for Art and Urban
Resources P.S.1, Long Island, New York
Collection P.S.1, Long Island, New York
Gift/Schenkung: Richard Serra
Illustrated page/Abbildung Seite 39

Unequal Elevations, 1975
Steel/Stahl
2 blocks/Blöcke
12 x 24 x 12 in / 30.5 x 61 x 30.5 cm
10 x 24 x 12 in / 26.5 x 61 x 30.5 cm

Installed Leo Castelli Gallery, NYC, for the exhibition *Richard Serra*', 1975
Installiert in der Leo Castelli Gallery, New York, für die Ausstellung *Richard Serra*
Collection Solomon R. Guggenheim Museum, New York
Illustrated page/Abbildung Seite 42

Span: for Alexander and Gilbert, 1977
Hot rolled steel/Walzstahl
Overall/insgesamt
9 ft 11 in x 36 ft 3 in x 8 in
3.02 x 11.04 m x 20 cm
Installed Galerie Daniel Templon, Paris, for the exhibition *Richard Serra*,
29 Jan. – 2 March 1977
Installiert in der Galerie Daniel Templon, Paris, für die Ausstellung *Richard Serra*
Illustrated page/Abbildung Seite 43

Unequal Corner Elevations, 1977
Forged steel/Schmiedestahl
2 blocks/Blöcke
17 x 17 x 17 in / 43 x 43 x 45 cm
17 x 17 x 18 in / 44 x 44 x 46.5 cm
Installed Galerie m, Bochum, 1977 for the exhibition *Richard Serra*,
March – June 1977
Installiert in der Galerie m, Bochum, für die Ausstellung *Richard Serra*

Splash, 1980
Lead/Blei
Hayward Gallery, London, for the exhibition *Pier + Ocean*,
8 May – 22 June 1980
Hayward Gallery, London, für die Ausstellung *Pier + Ocean*

Waxing Arcs, 1980
Hot rolled steel/Walzstahl
2 plates each/Platten je
9 ft 10 in x 40 ft 4 in x 1 in
3.00 x 12.29 m x 2 cm
Installed Museum Boymans-van Beuningen, Rotterdam, for the exhibition *Richard Serra*,
14 May – 25 June 1980
Installiert im Museum Boymans-van

Beuningen, Rotterdam, für die Ausstellung *Richard Serra*
Collection Museum Boymans-van Beuningen, Rotterdam
Illustrated page/Abbildung Seite 44

Extended Cantilever, 1980
Steel/Stahl
18 plates/Platten
9 at each end of the room, each
9 an jedem Raumende, je
6 ft 7 in x 14 ft 9 in x 1 in
2.00 x 4.50 m x 2 cm
Overall/insgesamt
6 ft 7 in x 106 ft 6 in x 84 ft
2.00 x 32.46 x 25.60 m
Installed Museum Boymans-van Beuningen, Rotterdam, for the exhibition *Richard Serra*,
14 May – 25 June 1980
Installiert im Museum Boymans-van Beuningen, Rotterdam, für die Ausstellung *Richard Serra*

Elevator, 1980
CorTen steel/CorTen Stahl
2 plates each/Platten je
3 in x 12 ft x 40 ft / 6 cm x 3.66 x 12.32 m
One plate at floor level, one plate cantilevered above
Eine Platte plan auf dem Boden liegend, eine Platte schwebend, auf Balkonbrüstung im ersten Stock aufgelegt
Installed Hudson River Museum, Yonkers, NYC, for the exhibition
Richard Serra: Elevator, Nov. – Dec. 1980
Installiert im Hudson River Museum, Yonkers, New York für die Ausstellung
Richard Serra: Elevator
Illustrated page/Abbildung Seite 45

Slice, 1980
CorTen steel/CorTen Stahl
10 ft x 124 ft 6 in x 2 in
3.04 x 37.95 m x 5 cm
Installed Leo Castelli Gallery, NYC, for the exhibition *Richard Serra: Slice*,
28 February – 4 April 1981
Installiert in der Leo Castelli Gallery, New

York, für die Ausstellung *Richard Serra: Slice*
Illustrated pages/Abbildungen Seite 46, 47

Splash, 1981
Messehallen der Stadt Köln, Cologne, for the exhibition *Westkunst*,
30 May – 16 Aug. 1981
Messehallen der Stadt Köln, für die Ausstellung *Westkunst*

Plunge, 1983
CorTen steel/CorTen Stahl
2 slabs each/Brammen je
8 x 8 ft x 9 in / 2.43 x 2.43 m x 23 cm
Installed Larry Gagosian Gallery, Los Angeles, for the exhibition *Richard Serra*,
14 May – 25 June 1983
Installiert in der Larry Gagosian Gallery, Los Angeles, für die Ausstellung *Richard Serra*
Collection Pentti Kouri, Greenwich, Connecticut

Wall to Wall, 1983
Hot rolled steel/Walzstahl
8 plates propped between 2 walls, each
8 Platten, die durch den Druck zweier Wände in der Vertikalen gehalten werden, je
4 ft 6 in x 4 ft 6 in x 2 in
1.37 x 1.37 m x 5 cm
Overall/insgesamt
4 ft 6 in x 36 ft 2 in / 1.37 x 10.98 m x 5 cm
Installed Akira Ikeda Gallery, Tokyo, for the exhibition *Richard Serra: A New Sculpture*,
6 June – 30 July 1983
Installiert in der Akira Ikeda Gallery, Tokio, für die Ausstellung *Richard Serra: A New Sculpture*
Collection Akira Ikeda Gallery, Tokyo
Illustrated pages/Abbildung Seite 48, 49

Seven Corner Elevations, 1984
Forged steel/Schmiedestahl
7 blocks each/Blöcke je
33 x 21 x 21 in / 84 x 53 x 53 cm
Installed Galerie Templon, Paris, for the exhibition *Richard Serra: Sculpture*,
15 Sept. – 20 Oct. 1984

Installiert in der Galerie Templon, Paris, für die Ausstellung *Richard Serra: Sculpture*

Marguerite and Philibert, 1985
Forged steel/Schmiedestahl
2 blocks/Blöcke
4 ft 7 in x 4 ft 7 in / 1.40 x 1.40 m x 53 cm
4 ft 1 in x 4 ft 1 in x 21 in
1.24 x 1.24 m x 53 cm
Installed in the large cloister of the Cathédrale de Brou, Bourg-en-Bresse
Installiert in dem großen Kreuzgang der Kathedrale von Brou, Bourg-en-Bresse
Collection Commande publique de l'Etat pour la Cathédrale de Brou, Bourg-en-Bresse
Illustrated pages/Abbildungen Seite 52, 53

Unequal Corner Elevations, 1985
Forged steel/Schmiedestahl
2 blocks/Blöcke
17 x 17 x 18 in
17 x 17 x 18 in
43 x 43 x 45 cm
44 x 44 x 46.5 cm
Installed Museum Haus Lange, Krefeld, for the exhibition *Richard Serra*,
27 Jan. – 24 March 1985
Installiert im Museum Haus Lange, Krefeld, für die Ausstellung *Richard Serra*
Private Collection, Moers

Mies' Corner Extended, 1985
Steel/Stahl
2 plates/Platten
7 ft 11 in x 7 ft 11 in x 1 in
7 ft 11 in x 16 ft 1 in x 1 in
2.41 x 2.41 m x 2 cm
2.41 x 4.90 m x 2 cm
Installed Museum Haus Lange, Krefeld, for the exhibition *Richard Serra*,
27 Jan. – 24 March 1985
Installiert im Museum Haus Lange, Krefeld, für die Ausstellung *Richard Serra*

Klein's Wall, 1985
Hot rolled steel/Walzstahl
2 plates each/Platten je
9 ft 4 in x 6 ft 7 in x 1 in
2.84 x 2.00 m x 2 cm

Installed Museum Haus Lange, Krefeld, for
the exhibition *Richard Serra*,
27 Jan. – 24 March 1985
Installiert im Museum Haus Lange, Krefeld,
für die Ausstellung *Richard Serra*

Sacco and Vanzetti, 1986
CorTen steel/CorTen Stahl
3 plates/Platten
10 x 30 ft x 1$^1/_2$ in / 3.05 x 9.14 m x 4 cm
10 x 18 ft x 1$^1/_2$ in / 3.05 x 5.49 m x 4 cm
10 x 12 ft x 1$^1/_2$ in / 3.05 x 3.66 m x 4 cm
Installed Leo Castelli Gallery, NYC, for the
exhibition *Richard Serra*, 1986
Installiert in der Leo Castelli Gallery,
New York, für die Ausstellung
Richard Serra
Saatchi Collection, London
Illustrated page/Abbildung Seite 54

Casting, 1986
Lead/Blei
Approx./ca. 26 x 12 ft / 7.92 x 3.66 m
Museum of Modern Art, NYC, for the
exhibition *Richard Serra, Sculpture*,
27 Feb. – 19 May 1986
Museum of Modern Art, New York, für die
Ausstellung *Richard Serra, Sculpture*

Two Corner Curve, 1986
Hot rolled steel/Walzstahl
10 x 60 ft x 1 in / 3.04 x 18.28 m x 2 cm
Installed Museum of Modern Art, NYC, for
the exhibition *Richard Serra, Sculpture*,
27 Feb. – 19 May 1986
Installiert im Museum of Modern Art, New
York, für die Ausstellung *Richard Serra,
Sculpture*

Splash, 1986
Lead/Blei
Palacio de Velásquez, Madrid,
for the exhibition *Entre la
geometria y el Gesto: North American
Sculpture 1965-75*,
23 May – 21 July 1986
Palacio de Velásquez, Madrid,
für die Ausstellung *Entre la geometria y el
Gesto: North American Sculpture*

**Equal Parallel Elevation
Guernica – Bengazi,** 1986
Hot rolled steel/Walzstahl
4 blocks/Blöcke
2 blocks each/Blöcke je
4 ft 10 in x 16 ft 5 in x 9 in
4 ft 10 in x 4 ft 9 in x 9 in
1.48 x 5.00 m x 24 cm
1.48 x 1.45 m x 24 cm
Installed Museo Nacional Reina Sofia,
Madrid, for the exhibition
*Richard Serra: Un Encuentro Artistico en el
Tiempo*
26 May – 15 Sept. 1986
Installiert im Museo Nacional Reina Sofia,
Madrid für die Ausstellung *Richard Serra: Un
Encuentro Artistico en el Tiempo*
Collection Museo Nacional Reina Sofia,
Madrid
Illustrated page/Abbildung Seite 51

Crossroads, 1986
Hot rolled steel/Walzstahl
4 elements/Elemente
2 plates each/Platten je
4 ft 9 in x 20 ft x 8 in
1.44 x 6.10 m x 20 cm
2 blocks each/Blöcke je
4 ft 9 in x 32 x 8 in
1.44 m x 81 x 20 cm
Installed Hoffman Borman Gallery, Los
Angeles, for the exhibition *Richard Serra:
Major Sculpture*,
2 Dec. 1986 – 27 Jan. 1987
Installiert in der Hoffman Borman Gallery,
Los Angeles, für die Ausstellung *Richard
Serra: Major Sculpture*

Spiral Sections, 1986/87
CorTen steel/CorTen Stahl
4 curved plates/Kurven
Overall/insgesamt
98 ft 6 in x 86 ft x 1 in
30.02 x 26.21 m x 2 cm
Installed Kassel for the exhibition
documenta 8,
12 June – 20 Sept. 1987
Installiert auf der *documenta 8*, Kassel
Illustrated pages/Abbildungen Seite 55-57

Elevations Lenbachhaus, 1987
Forged steel/Schmiedestahl
2 blocks each/Blöcke je
4 ft 5 in x 32 x 22 in
1.34 m x 84 x 58 cm
Installed Städtische Galerie im
Lenbachhaus, Munich, for the exhibition
Richard Serra: 7 Spaces – 7 Sculptures,
26 Nov. 1987 – 28 Feb. 1988
Installiert in der Städtischen Galerie im
Lenbachhaus, München, für die Ausstellung
Richard Serra: 7 Spaces – 7 Sculptures
Collection Städtische Galerie im
Lenbachhaus, München

Vise, 1987
Steel/Stahl
2 plates each/Platten je
4 ft 11 in x 4 ft 11 in x 8 in
1.50 x 1.50 m x 20 cm
Installed Städtische Galerie im
Lenbachhaus, Munich, for the exhibition
Richard Serra: 7 Spaces – 7 Sculptures,
26 Nov. 1987 – 28 Feb. 1988
Installiert in der Städtischen Galerie im
Lenbachhaus, München, für die Ausstellung
Richard Serra: 7 Spaces – 7 Sculptures
Collection Städtische Galerie im
Lenbachhaus, München
Illustrated page/Abbildung Seite 59

Opposite Corners Bisected, 1987
Steel/Stahl
2 plates each/Platten je
7 ft 11 in x 24 ft x 1 in / 2.41 x 7.30 m x 2 cm
Installed Städtische Galerie im
Lenbachhaus, Munich, for the exhibition
Richard Serra: 7 Spaces – 7 Sculptures,
26 Nov. 1987 – 28 Feb. 1988
Installiert in der Städtischen Galerie im
Lenbachhaus, München, für die Ausstellung
Richard Serra: 7 Spaces – 7 Sculptures
Collection Städtische Galerie im
Lenbachhaus, München
Illustrated page/Abbildung Seite 64

Gate, 1987
Forged steel/Schmiedestahl
4 bars/Balken

2 verticals each/Stützen je
13 x 13 x 12 in / 33 x 33 x 30 cm
2 horizontals/Querbalken
13 x 13 in x 17 ft 2 in / 33 x 33 cm x 5.23 m
13 x 13 in x 14 ft 9 in / 33 x 33 cm x 4.49 m
Installed Städtische Galerie im
Lenbachhaus, Munich, for the exhibition
Richard Serra: 7 Spaces – 7 Sculptures,
26 Nov. 1987 – 28 Feb. 1988
Installiert in der Städtischen Galerie im
Lenbachhaus, München, für die Ausstellung
Richard Serra: 7 Spaces – 7 Sculptures
Collection Städtische Galerie im
Lenbachhaus, München
Illustrated page/Abbildung Seite 63

Cornered, 1987
CorTen steel/CorTen Stahl
2 plates/Platten
14 x 27 ft x 2 in / 4.27 x 8.23 m x 5 cm
14 x 16 ft 9 in x 2 in / 4.27 x 5.10 m x 5 cm
Installed Leo Castelli Gallery, NYC, for the
exhibition *Richard Serra,* 1987
Installiert in der Leo Castelli Gallery, New
York, für die Ausstellung *Richard Serra*
Illustrated pages/Abbildungen Seite 60, 61

Timber, 1988
Steel/Stahl
2 plates/Platten
13 ft 2 in x 9 ft 10 in x 1 in
9 ft 10 in x 19 ft 10 in x 1 in
4.00 x 2.99 m x 2 cm
2.99 x 6.04 m x 2 cm
Installed Nationalgalerie Berlin, for the
exhibition *Positionen heutiger Kunst,*
23 June – 18 Sept. 1988
Installiert in der Nationalgalerie, Berlin, für
die Ausstellung *Positionen heutiger Kunst*
Illustrated page/Abbildung Seite 65

Sesshu Screen, 1988
Steel/Stahl
1 plate/Platte
9 ft 10 in x 20 ft x 1 in
3.00 x 6.10 m x 2 cm
Installed Nationalgalerie Berlin, for the
exhibition *Positionen heutiger Kunst,*
23 June – 18 Sept. 1988

Installiert in der Nationalgalerie, Berlin, für die Ausstellung *Positionen heutiger Kunst*

Berlin Elliptical, 1988
Steel/Stahl
3 plates each/Platten je
8 ft 3 in x 28 ft 3 in x 1 in
2.51 x 8.61 m x 2 cm
Overall/insgesamt
13 ft 2 in x 68 ft 7 in x 19 ft 7 in
4.01 x 20.90 x 5.97 m
Installed Nationalgalerie Berlin, for the exhibition *Positionen heutiger Kunst*, 23 June – 18 Sept. 1988
Installiert in der Nationalgalerie, Berlin, für die Ausstellung *Positionen heutiger Kunst*

Siamese 67.5°, 1988
Hot rolled steel/Walzstahl
2 triangular plates each/dreieckige Platten je
9 ft 9 in x 27 ft 9 in x 1 in / 3.00 x 8.50 m x 3 cm
Installed Van Abbe Museum, Eindhoven, for the exhibition *Richard Serra: Ten Sculptures for Van Abbe*, 4 Sept. – 30 Oct. 1988
Installiert im Van Abbe Museum, Eindhoven, für die Ausstellung *Richard Serra: Ten Sculptures for Van Abbe*

Edgeways, 1988
Steel/Stahl
2 plates each/Platten je
8 ft 10 in x 36 ft 10 in x 18 ft 1 in
2.69 x 11.22 x 5.50 m
Installed Van Abbe Museum, Eindhoven, for the exhibition *Richard Serra: Ten Sculptures for Van Abbe*, 4 Sept. – 30 Oct. 1988
Installiert im Van Abbe Museum, Eindhoven, für die Ausstellung *Richard Serra: Ten Sculptures for Van Abbe*

T-Junction, 1988
Forged steel/Schmiedestahl
2 bars/Balken
Vertical/Stütze
10 x 10 in x 7 ft 11 in
25 x 25 cm x 2.38 m
Horizontal/Querbalken
8 ft 8 in x 25 ft 10 in x 10 in
2.64 x 7.87 m x 25 cm

Installed Van Abbe Museum, Eindhoven, for the exhibition *Richard Serra: Ten Sculptures for Van Abbe*, 4 Sept. – 30 Oct. 1988
Installiert im Van Abbe Museum, Eindhoven, für die Ausstellung *Richard Serra: Ten Sculptures for Van Abbe*
Collection Van Abbe Museum, Eindhoven
Illustrated page/Abbildung Seite 66

Maillart, 1988
Forged steel/Schmiedestahl
3 bars/Balken
2 verticals/Stützen
10 x 10 in x 7 ft 10 in / 25 x 25 cm x 2.38 m
1 horizontal/Querbalken
10 ft 10 in x 36 ft 10 in / 25 x 25 cm x 11.23 m
Installed Van Abbe Museum, Eindhoven, for the exhibition *Richard Serra: Ten Sculptures for Van Abbe*, 4 Sept. – 30 Oct. 1988
Installiert im Van Abbe Museum, Eindhoven, für die Ausstellung *Richard Serra: Ten Sculptures for Van Abbe*
Illustrated page/Abbildung Seite 67

Merel, 1988
Hot rolled steel/Walzstahl
4 plates each/Platten je
8 ft 8 in x 13 ft 4 in x 2 in
2.70 x 4.08 m x 4 cm
Installed Van Abbe Museum, Eindhoven, for the exhibition *Richard Serra: Ten Sculptures for Van Abbe*
4 Sept. – 30 Oct. 1988
Installiert im Van Abbe Museum, Eindhoven, für die Ausstellung *Richard Serra: Ten Sculptures for Van Abbe*

Sub Tend 60°, 1988
Steel/Stahl
2 plates each/Platten je
8 ft 10 in x 24 ft 11 in x 1 in
2.69 x 7.59 m x 2 cm
Installed Van Abbe Museum, Eindhoven, for the exhibition *Richard Serra: Ten Sculptures for Van Abbe*, 4 Sept. – 30 Oct. 1988
Installiert im Van Abbe Museum, Eindhoven, für die Ausstellung *Richard Serra: Ten Sculptures for Van Abbe*

Collection Pentti Kouri, Greenwich,
Connecticut
Illustrated page/Abbildung Seite 68

Chamber, 1988
Steel/Stahl
3 plates/Platten
2 plates each/Platten je
8 ft 10 in x 20 ft 4 in x 1 in
2.69 x 6.19 m x 2 cm
1 plate/Platte
8 ft 10 in x 13 ft 9 in x 1 in
2.69 x 4.19 m x 2 cm
Installed Van Abbe Museum, Eindhoven, for
the exhibition *Richard Serra: Ten Sculptures
for Van Abbe,* 4 Sept. − 30 Oct. 1988
Installiert im Van Abbe Museum, Eindhoven,
für die Ausstellung *Richard Serra: Ten Sculp-
tures for Van Abbe*
Illustrated page/Abbildung Seite 69

Lock, 1988
Steel/Stahl
1 plate/Platte
8 ft 10 in x 20 ft 8 in x 1 in
2.69 x 6.29 m x 2 cm
Installed Van Abbe Museum, Eindhoven, for
the exhibition *Richard Serra: Ten Sculptures
for Van Abbe,*
4 Sept. − 30 Oct. 1988
Installiert im Van Abbe Museum, Eindhoven,
für die Ausstellung *Richard Serra: Ten Sculp-
tures for Van Abbe*

Spaces Elevations, 1989
Steel/Stahl
9 plates/Platten
3 plates each/Platten je
5 ft x 8 in x 7 ft / 1.50 m x 20 cm x 2.13 m
3 plates each/Platten je
5 ft 6 in x 8 in x 7 ft
1.40 m x 20 cm x 2.13 m
3 plates each/Platten je
4 ft x 8 in x 7 ft / 1.22 x 20 cm x 2.13 m
Installed Donald Young Gallery, Chicago,
for the exhibition *Richard Serra,*
29 June − 15 Sept. 1989
Installiert in der Donald Young Gallery,
Chicago, für die Ausstellung *Richard Serra*

Sesshu Sesshu, 1989
Steel/Stahl
2 plates each/Platten je
10 x 14 ft 9 in x 2 in / 3.04 x 4.50 m x 5 cm
Installed Pace Gallery, NYC, for the
exhibition *Richard Serra: Sculpture,*
15 Sept. − 14 Oct. 1989
Installiert in der Pace Gallery, New York, für
die Ausstellung *Richard Serra: Sculpture*
Collection Pentti Kouri, Greenwich,
Connecticut

Blackmun & Brennan, 1989
Forged steel/Schmiedestahl
Post and lintel construction/
Pfosten und Sturz
Overall/insgesamt
9 ft 8 in x 36 ft 10 in x 10 in
2.95 x 11.23 m x 25 cm
Installed Pace Gallery, NYC, for the
exhibition *Richard Serra: Sculpture,*
15 Sept. − 14 Oct. 1989
Installiert in der Pace Gallery, New York, für
die Ausstellung *Richard Serra: Sculpture*
Collection Pentti Kouri, Greenwich,
Connecticut

Stacks, 1989
Hot rolled steel/Walzstahl
2 elements each/Elemente je
7 ft 9 in x 8 ft x 10 in / 2.36 x 2.43 m x 25 cm
Installed Yale University Art Gallery, New
Haven, Connecticut
Installiert in der Yale University Art Gallery,
New Haven, Connecticut
Collection Yale University Art Gallery, New
Haven, Connecticut, Katherine Ordway Fund
Illustrated pages/Abbildung Seite 70, 71

Casting, 1990
Lead/Blei
10 x 14 ft x 14 in
2.04 x 4.27 m x 36 cm
Whitney Museum of American Art, NYC, for
the exhibition *The New Sculpture 1965-75:
Between Geometry and Gesture,*
1 March − 6 June 1990
Whitney Museum of American Art, New
York, für die Ausstellung

The New Sculpture 1965-75: Between Geometry and Gesture

The Hours of the Day, 1990
Hot rolled steel/Walzstahl
4 plates each/Platten je
6 x 6 ft 10 in x 6 in / 1.82 x 2.08 m x 15 cm
5 ft 6 in x 16 ft 10 in x 6 in
1.67 x 5.12 m x 15 cm
5 x 16 ft 10 in x 6 in / 1.52 x 5.12 m x 15 cm
4 ft 6 in x 16 ft 10 in x 6 in
1.37 x 5.12 m x 15 cm
Installed Kunsthaus Zürich, Zurich,
for the exhibition *Richard Serra: The Hours of the Day*,
8 March − 26 April 1990
Installiert im Kunsthaus Zürich, Zürich,
Schweiz, für die Ausstellung *Richard Serra: The Hours of the Day*
Illustrated pages/Abbildungen Seite 72-75

Threats of Hell, 1990
Carbon steel/Walzstahl
3 plates each/Platten je
15 x 15 ft x 10 in
4.60 x 4.60 m x 25 cm
Installed capc Musée d'art contemporain de Bordeaux, for the exhibition *Richard Serra: Threats of Hell*,
June 1990 − Jan. 1991
Installiert im capc Musée d'art contemporain de Bordeaux für die Ausstellung *Richard Serra: Threats of Hell*
Collection Christian Moueix, Bordeaux
Illustrated page/Abbildung Seite 76

Casting, 1991
Lead/Blei
Approx/ca.
10 x 15 ft x 14 in
3.05 x 4.57 m x 36 cm
Museum of Contemporary Art, Los Angeles,
for the exhibition *The New Sculpture 1965-75: Between Geometry and Gesture*,
16 Feb. − 1 June 1991
Museum of Contemporary Art, Los Angeles,
für die Ausstellung
The New Sculpture 1965-75: Between Geometry and Gesture

Two Forged Rounds for Buster Keaton, 1991
Forged steel/Schmiedestahl
2 rounds each/Rundstücke je
5 ft 4 in x 7 ft 5 in / 1.62 x 2.26 m
Installed Gagosian Gallery, NYC, for the
exhibition *Richard Serra: Sculpture and Drawings*, 2 Nov. 1991 − 11 Jan. 1992
Installiert in der Gagosian Gallery, New
York, für die Ausstellung *Richard Serra: Sculpture and Drawings*
Collection Robert and Jane Meyerhoff,
Phoenix
Illustrated page/Abbildung Seite 77

Holocaust Museum Installation, 1991-92
CorTen steel/CorTen Stahl
12 x 12 ft x 10 in
3.66 x 3.66 m x 25 cm
Installed US Holocaust Memorial Museum,
Washington DC
Installiert im US Holocaust Museum,
Washington DC

Casting, 1992
Lead/Blei
17 in x 43 ft 4 in / 42 cm x 13.20 m
Museo Nacional Reina Sofia, Madrid, for
the exhibition *Richard Serra*,
28 Jan. − 23 March 1992
Museo Nacional Reina Sofia, Madrid, für
die Ausstellung *Richard Serra*

Splashing, 1968/92
Lead/Blei
Length approx./Länge ca.
24 ft / 7.40 m
Collection De Pont Foundation for Contemporary Art, Tilburg, The Netherlands
Illustrated page/Abbildung Seite 78

Splash Piece: Casting, 1969/92
Lead/Blei
2 and 3 angles / 2 und 3 Winkel
Approx./ca.
4 x 5 x 5 ft / 1.20 x 1.50 x 1.50 m
3 x 7 x 5 ft / 90 cm x 2.10 x 1.50 m
Collection De Pont Foundation for Contemporary Art, Tilburg, The Netherlands
Illustrated page/Abbildung Seite 79

Madrid Post & Lintel, 1992
Forged steel/Schmiedestahl
Vertical/Stütze
8 ft 10 in x 10 x 10 in / 2.70 m x 25 x 25 cm
Horizontal/Querbalken
24 ft x 10 x 10 in / 7.20 m x 25 x 25 cm
Installed Museo Nacional Reina Sofia,
Madrid, for the exhibition *Richard Serra*,
28 Jan. – 23 March 1992
Installiert im Museo Nacional Reina Sofia,
Madrid, für die Ausstellung *Richard Serra*

Plow, 1992
CorTen steel/CorTen Stahl
2 plates each/Platten je
7 x 7 ft x 10 in / 2.13 x 2.13 m x 25 cm
Installed Museo Nacional Reina Sofia,
Madrid, for the exhibition *Richard Serra*,
28 Jan. – 23 March 1992
Installiert im Museo Nacional Reina Sofia,
Madrid, für die Ausstellung *Richard Serra*

The Drowned and the Saved, 1992
Forged steel/Schmiedestahl
2 right angled elements each/Winkelele-
mente je
4 ft 10 in x 5 ft 3 in x 14 in
1.47 x 1.55 m x 35 cm
Installed Synagogue Stommeln, Germany,
for the exhibition *The Drowned and the Saved*
24 March – 13 Sept. 1992
Installiert in der Synagoge Stommeln,
Deutschland für die Ausstellung *The
Drowned and the Saved*
Illustraded pages/Abbildungen Seite 80, 81

Running Arcs (For John Cage), 1992
CorTen steel/CorTen Stahl
3 conical elements each/konische Elemente je
13 ft 1 in x 55 ft 9 in x 2 in / 4.00 x 17.00 m x 5 cm
Installed Kunstsammlung Nordrhein-
Westfalen, Düsseldorf, for the exhibition
Richard Serra: Running Arcs (For John Cage),
11 Sept. – 13 Dec. 1992
Installiert in der Kunstsammlung
Nordrhein-Westfalen, Düsseldorf, für die
Ausstellung *Richard Serra: Running Arcs (For
John Cage)*
Illustrated pages/Abbildung Seite 82, 83

Weight and Measure, 1992
Forged steel/Schmiedestahl
2 blocks/Blöcke
68 x 41 x 108½ in / 1.73 x 1.04 x 2.75 m
60 x 41 x 108½ in / 1.52 x 1.04 x 2.75 m
Installed Tate Gallery, London, for the
exhibition *Richard Serra: Weight and Measure*,
30 Sept. 1992 – 15 Jan. 1993
Installiert in der Tate Gallery, London, für
die Ausstellung *Richard Serra: Weight and
Measure*
Illustrated pages/Abbildungen Seite 85-89

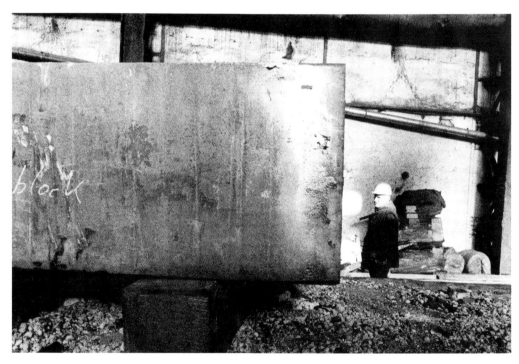

Richard Serra at the steel mill with / in der Henrichshütte mit: *Weight and Measure*, 1992

Born November 2nd, 1939,
in San Francisco, California, USA.
Lives and works in New York City,
New York, USA and Inverness,
Nova Scotia, Canada.

Geboren am 2. November 1939
in San Francisco, California/USA.
Lebt und arbeitet in New York City,
New York/USA und Inverness,
Nova Scotia/Canada.

Selected exhibitions

Ausstellungen in Auswahl

1966 Galleria La Salita, Roma
1968 Galerie Ricke, Köln
1969 Leo Castelli Warehouse, New York
Op Losse Schroeven, situaties en crypto-structuren (Square Pegs in Round Holes).
Stedelijk Museum, Amsterdam
When Attitudes Become Form. Kunst-halle Bern; Haus Lange, Krefeld;
ICA, London
Anti-Illusion: Procedures/Materials.
Whitney Museum of American Art,
New York
1970 University of California, San Diego
Pasadena Art Museum, Pasadena,
California
1972 *documenta 5*, Kassel
1973 Galerie Ricke, Köln
1974 Leo Castelli Gallery, New York
1975 Portland Center for the Visual Arts,
Portland, Oregon
1976 Ace Gallery, Los Angeles
1977 Galerie m, Bochum
Drawings, 1971-1977. Stedelijk Museum,
Amsterdam; Kunsthalle Tübingen;
Staatliche Kunsthalle, Baden-Baden
documenta 6, Kassel
1978 *Works 66-77*. Kunsthalle Tübingen;
Staatliche Kunsthalle, Baden-Baden
1979 *Sculpture, Films 1966-1978*. Staatliche
Kunsthalle, Baden-Baden
1980 Museum Boymans-van Beuningen,
Rotterdam
Elevator 1980. The Hudson River
Museum, Yonkers, New York

1982 *documenta 7*, Kassel
1983 Musée Nationale d'Art Moderne,
Centre Georges Pompidou, Paris
1985 Museum Haus Lange, Krefeld
1986 *Sculpture*. Museum of Modern Art,
New York
Drawings. Louisiana Museum,
Humlebaek
1987 *documenta 8*, Kassel
Zeichnungen. Westfälisches Museum für
Kunst und Kulturgeschichte, Münster
7 Spaces − 7 Sculptures. Städtische
Galerie im Lenbachhaus, München
1988 Kunsthalle Basel
Ten Sculptures for the Van Abbe.
Stedelijk van Abbemuseum, Eindhoven
1990 *Tekeningen*. Bonnefantenmuseum,
Maastricht
The Hours of the Day. Kunsthaus Zürich
Threats of Hell. capc Musée d'art
contemporain, Bordeaux
1991 *Drei Zeichnungen*. Städtische Galerie
im Staedelschen Kunstinstitut,
Frankfurt/Main
Malmö Konsthall, Malmö
The Afangar Icelandic Series.
Museum of Modern Art, New York
1992 Museo Nacional Reina Sofia,
Madrid
The Drowned and the Saved. Synagoge
Stommeln, Pulheim
Weight and Measure. Tate Gallery,
London
Drawings. Serpentine Gallery, London

Ways of giving to the Tate Gallery

The Tate Gallery attracts funds from the private sector to support its programme of activities in London, Liverpool and St Ives. Support is raised from the business community, individuals, trusts and foundations, and includes sponsorships, donations, bequests and gifts of works of art. The Tate Gallery is recognised as a charity under Inland Revenue reference number x78055/1.

Trustees

Dennis Stevenson CBE (Chairman)

The Countess of Airlie CVO
Michael Craig-Martin
The Hon. Mrs Janet de Botton
Richard Deacon
William Govett
Christopher Le Brun
David Puttnam CBE
Sir Rex Richards
Paula Ridley
David Verey

Individual Membership Programmes

FRIENDS OF THE TATE GALLERY

Since their formation in 1958, the Friends of the Tate Gallery have helped to buy major works of art for the Tate Gallery collection, from Stubbs to Hockney.

Members are entitled to immediate and unlimited free admission to Tate Gallery exhibitions with a guest, invitations to previews of Tate Gallery exhibitions, opportunities to visit the Gallery when closed to the public, a discount of 10 per cent in the Tate Gallery shop, special events, *Friends Events* and *Tate Preview* magazines mailed three times a year, free admission to exhibitions at Tate Gallery Liverpool, and use of the new Friends Room at the Tate Gallery, supported by Lloyd's of London.

Three categories of higher level memberships, Associate Fellow at £ 100, Deputy Fellow at £ 250, and Fellow at £ 500, entitle members to a range of extra benefits including guest cards and invitations to exclusive special events.

The Friends of the Tate Gallery are supported by Tate & Lyle PLC.

Further details on the Friends may be obtained from:

Friends of the Tate Gallery
Tate Gallery
Millbank
London SW1P 4RG

Tel.: 071-834 2742

PATRONS OF THE TATE GALLERY

The Patrons of British Art support British painting and sculpture from the Eliza-

bethan period through to the early twentieth century in the Tate Gallery's collection. They encourage knowledge and awareness of British Art by providing an opportunity to study Britain's cultural heritage.

The Patrons of New Art support contemporary art in the Tate Gallery's collection. They promote a lively and informed interest in contemporary art and are associated with the Turner Prize, one of the most prestigious awards for the visual arts.

Annual membership of the Patrons ranges from £350 to £750, and funds the purchase of works of art for the Tate Gallery's collection.

Benefits for both groups include invitations to Tate Gallery receptions, an opportunity to sit on the Patron's acquisitions committees, special events including visits to private and corporate collections and complimentary catalogues of Tate Gallery exhibitions.

Further details on the Patrons may be obtained from:

The Development Office
Tate Gallery
Millbank
London SWIP 4RG

Corporate Membership Programme

Membership of the Tate Gallery's Corporate Membership Programme offers companies outstanding value-for-money and provides opportunites for every employee to enjoy a closer knowledge of the Gallery, its collection and exhibitions.

Membership benefits are specifically geared to business needs and include private views for company employees, free and discount admission to exhibitions, discount in the Gallery shop, out-of-hours Gallery visits, behind-the-scenes tours, exclusive use of the Gallery for corporate entertainment, invita-

tions to VIP events, copies of Gallery literature and acknowledgement in Gallery publications.

TATE GALLERY CORPORATE
MEMBERS

Partners
Agfa Gevaert Ltd
Barclays Bank PLC
The British Petroleum Company plc
Glaxo Holdings p.l.c.
Manpower (UK) Ltd
THORN EMI
Unilever

Associates
Bell Helicopter Textron
Channel 4 Television
Debenham Tewson & Chinnocks
Ernst & Young
Global Asset Management
KPMG Peat Marwick
Lazard Brothers & Co Ltd
Linklaters & Paines
Smith & Williamson
S.G. Warburg Group
Vickers plc

Corporate Sponsorship

The Tate Gallery works closely with sponsors to ensure that their business interests are well served, and has a reputation for developing imaginative fund-raising initiatives. Sponsorships can range from a few thousand pounds to considerable investment in long-term programmes; small businesses as well as multinational corporations have benefited from the high profile and prestige of Tate Gallery sponsorship.

Opportunities available at Tate Gallery London, Liverpool and St Ives include exhibitions (some also tour the UK), education, conservation and research programmes, audience development, visitor access to the

collection and special events. Sponsorship benefits include national and regional publicity, targeted marketing to niche audiences, exclusive corporate entertainment, employee benefits and acknowledgment in Tate Gallery publications.

Barclays Bank PLC
 1991, *Constable*
The British Land Company PLC
 1990-4, *Joseph Wright of Derby**
The British Petroleum Company plc
 1990, *New Displays*
Channel 4 Television
 1990-3, The Turner Prize
Daimler-Benz AG
 1991, *Max Ernst*
Pearson plc
 1992-5 Elizabethan Curator Post
Reed International P.L.C.
 1990, *On Classic Ground: Picasso, Léger, de Chirico and the New Classicism, 1910-30*
Tatle & Lyle PLC
 1991-3, Friends Relaunch Marketing Programme
Volkswagen
 1990-2, The Turner Scholarships

Agfa Graphic Systems Group
 1992, *Turner: The Fifth Decade**
Beck's
 1992, *Otto Dix*
Blackwall Green Ltd
 1991, International Conference on the Packing and Transportation of Paintings
Borghi Transporti Spedizioni SPA
 1991, International Conference on the Packing and Transportation of Paintings
James Bourlets & Sons
 1991, International Conference on the Packing and Transportation of Paintings

British Steel plc
 1990, *William Coldstream*
Carrol, Dempsey & Thirkell
 1990, *Anish Kapoor**
Clifton Nurseries
 1990-2, Christmas Tree (in kind)
D'Art Kunstspedition GmbH
 1991, International Conference on the Packing and Transportation of Paintings
Debenham Tewson & Chinnocks
 1990, *Turner: Painting and Poetry*
Digital Equipment Co Ltd
 1991-2, *From Turner's Studio*
Gander and White Shipping Ltd
 1991, International Conference on the Packing and Transportation of Paintings
Gerlach Art Packers & Shippers
 1991, International Conference on the Packing and Transportation of Paintings
Harsch Transports
 1991, International Conference on the Packing and Transportation of Paintings
Hasenkamp Internationale Transporte
 1991, International Conference on the Packing and Transportation of Paintings
The Independent
 1992, *Otto Dix* (in kind)
KPMG Management Consulting
 1991, *Anthony Caro: Sculpture towards Architecture**
Kunsttrans Antiquitaten
 1991, International Conference on the Packing and Transportation of Paintings
Lloyd's of London
 1991, Friends Room
Martinspeed Ltd
 1991, International Conference on the Packing and Transportation of Paintings
Mat Securitas Express AG
 1991, International Conference on the Packing and Transportation of Paintings

Mobel Transport AG
 1991, International Conference
 on the Packing and Transportation
 of Paintings
Momart plc
 1991, International Conference
 on the Packing and Transportation
 of Paintings
Propileo Transport
 1991, International Conference
 on the Packing and Transportation
 of Paintings
Rees Martin Art Service
 1991, International Conference
 on the Packing and Transportation
 of Paintings
SRU Limited
 1992, *Richard Hamilton**
TSB Group plc
 1992, *Turner and Byron*
 1992-5, *William Blake* display series
Wingate & Johnston Ltd
 1991, International Conference
 on the Packing and Transportation
 of Paintings

* denotes a first-time sponsorship in the
arts, recognised by an award under the
Government's Business Sponsorship Incentive
Scheme, administered by the Association
for Business Sponsorship of the Arts.

TATE GALLERY LIVERPOOL:
CORPORATE SPONSORS

AIB Bank
 1991, *Strongholds*
Barclays Bank PLC
 1990, *New Light On Sculpture*
BASF
 1990, *Lifelines*
British Alcan Aluminium plc
 1991, *Dynamism*
 1991, *Giacometti*
British Telecom plc
 1990, Outreach Programme
Concord Lighting
 1990, *New Light on Sculpture*

Cultural Relations Committee,
Department of Foreign Affairs, Ireland
 1991, *Strongholds*
English Estates
 1991, Mobile Art Programme
Granada Television plc
 1990, *New North*
Korean Air
 1992, *Working with Nature* (in kind)
The Littlewoods Organisation plc
 1992-5, *New Realities*
Merseyside Development Corporation
 1990, Outreach Programme
 1992, *Myth-Making*
 1992, *Stanley Spencer*
Mobil Oil Company Ltd
 1990, *New North*
Momart plc
 1990-2, The Momart Fellowship
NSK Bearings Europe Ltd
 1991, *A Cabinet of Signs: Contemporary Art
 from Post-Modern Japan*
Ryanair
 1991, *Strongholds* (in kind)
Samsung Electronics
 1992, *Working With Nature*
Volkswagen
 1991, Mobile Art Programme (in kind)

Tate Gallery Benefactors

London, Liverpool and St Ives

FOUNDING BENEFACTORS

Sir Henry Tate
Sir Joseph Duveen
Lord Duveen
The Clore Foundation

PRINCIPAL BENEFACTORS

American Fund for the Tate Gallery
Calouste Gulbenkian Foundation
The Henry Moore Foundation

National Heritage Memorial Fund
National Art Collections Fund
The Nomura Securities Co., Ltd
Dr Mortimer and Theresa Sackler
 Foundation
The Wolfson Foundation and Family
 Charitable Trust

BENEFACTORS

The Baring Foundation
Mr Edwin C. Cohen
John S. Cohen Foundation
Gilbert and Janet de Botton
The John Ellerman Foundation
Esmée Fairbairn Charitable Trust
The Foundation for Sport and the Arts
The Getty Grant Program
Granada Group plc
John and Olivia Hughes
The Leverhulme Trust
John Lewis Partnership
Museums and Galleries Improvement Fund
Ocean Group plc (P.H. Holt Trust)
The Pilgrim Trust
GEC Plessey Telecommunications
The Eleanor Rathbone Charitable Trust
Mr John Ritblat
The Sainsbury Family Charitable Trust
Save & Prosper Educational Trust
SRU Limited
Bernard Sunley Charitable Foundation
Weinberg Foundation

Photographic credits / Photonachweis

Cover / Schutzumschlag
Stefan Erfurt, Wuppertal

Frontispiece / Frontispiz
Richard Serra 1987
photographed by / photographiert von
Nancy Lee Katz

Jon Abbott, New York
 p./S. 45
Akiyoshi Terashima, Tokyo
 p./S. 48, 49
Hans Biezen, Tilburg, The Netherlands
 p./S. 78, 79
Musée de Brou, Bourg-en-Bresse, France
 p./S. 52, 53
Balthasar Burkhard, Boisset et Gaujac,
France
 p./S. 35, 36, 37, 72, 73, 74, 75
Leo Castelli Gallery, New York
 p./S. 42, 54
Centro de Arte Reiner Sofia, Madrid
 p./S. 51
Bevan Davies, New York
 p./S. 46, 47
F. Delpech, capc Musée d'art contemporain
de Bordeaux
 p./S. 76
Roy Elkind, Los Angeles
 p./S. 38
Stefan Erfurt/F.A.Z. Magazin
 p./S. 7, 10, 14, 16, 20, 22, 25, 102
Huger Foote, New York
 p./S. 77

Tina Girouard, New York
 p./S. 39
Gianfranco Gorgoni, New York
 p./S. 30
Werner Hannappel, Essen
 p./S. 34, 63, 64, 65, 66, 67, 68, 69, 80,
 81, 82, 83
Bill Jacobson, New York
 p./S. 60, 61
Michael Marsland, Yale University
 p./S. 70, 71
Gordon Matta-Clark
 p./S. 41
Peter Moore, New York
 p./S. 31, 33
André Morain, Paris
 p./S. 43
National Gallery of Canada, Ottawa
 p./S. 32
Dirk Reinartz, Buxtehude
 p./S. 55, 56, 57
Harry Shunk, New York
 p./S. 28, 29
Shunk-Kender, New York
 p./S. 27
Gian Sinigaglia, Milano
 p./S. 40
Städtische Galerie im Lenbachhaus,
München
 p./S. 59
Dick Wolters, Overzande, The Netherlands
 p./S. 44

Published by order of the Trustees 1992
on the occasion of the exhibition at the Tate Gallery
30 September 1992 – 15 January 1993
Published by Tate Gallery Publications
and Richter Verlag

Printed and bound by/Gesamtherstellung
Druckerei Heinrich Winterscheidt GmbH
Düsseldorf, Germany

*A detailed biography, bibliography and list
of exhibitions is published with the hardcover edition
of the catalogue by Richter Verlag Düsseldorf.*

*Eine ausführliche Biographie, Bibliographie sowie ein
umfassendes Ausstellungsverzeichnis ist mit der
Buchhandelsausgabe des Kataloges im Richter Verlag
Düsseldorf erschienen.*

ISBN 1-85437-109-6
Tate Gallery, London
Richard Serra. Weight and Measure 1992

ISBN 3-928762-07-9
Richter Verlag Düsseldorf
Richard Serra:
Running Arcs (For John Cage)
Weight and Measure 1992
Drawings
Bookshop edition three volumes in a box
Buchhandelsausgabe der drei Bände im Schuber